GRAVEYARD ART & SYMBOLISM

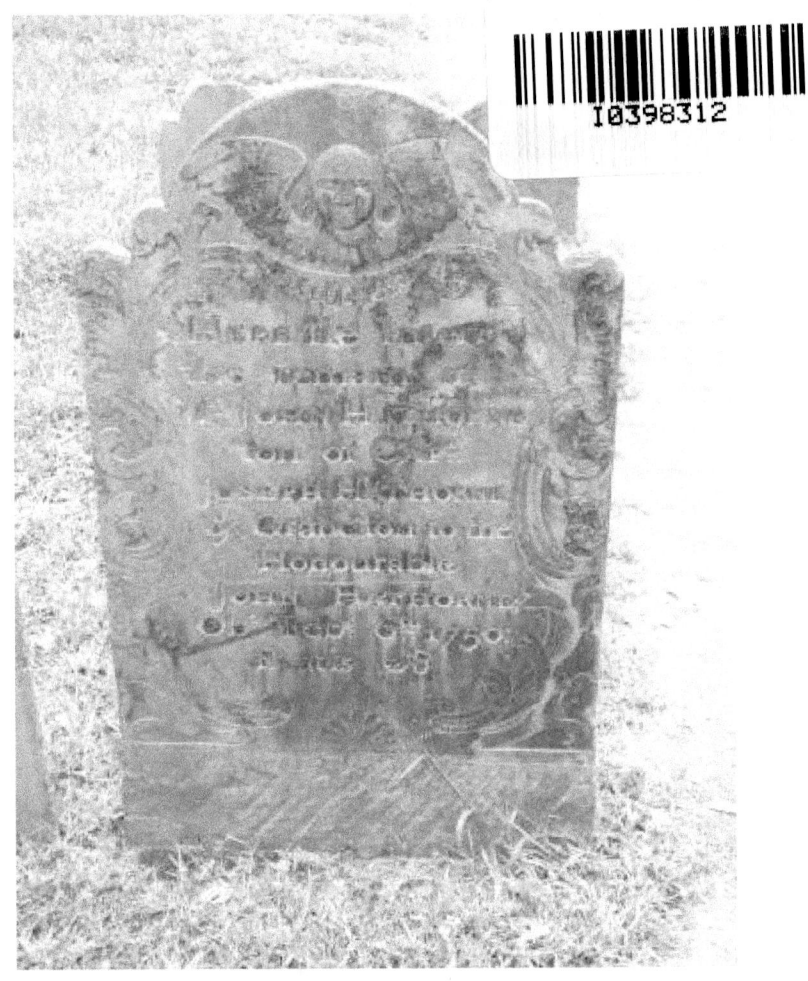

Written and photographed by
Gary R. Varner

Graveyard Art & Symbolism

Copyright © 2024 by Gary R. Varner

All rights reserved

ISBN: 978-1-304-05564-4

First edition published in paperback as Remembrances of the Dead: Graveyard Art & Symbolism, copyright 2023 Lulu Press

Second Edition

An OakChylde Book

The photographs illustrating this book were taken by the author at the following locations:

Lexington Battlefield, Lexington, Mass.
Charter Street Burying Ground, Salem, Mass.
Frankfort Cemetery, Frankfort, Kentucky
Kingston Presbyterian Church Cemetery, Conway, South Carolina
Lunenburg Cemetery, Lunenburg, Nova Scotia
Marysville Cemetery, Marysville, California
Oak Grove Cemetery, Falls River, Mass.
Sacramento Historical Cemetery, Sacramento, California
St. Canice Historical Cemetery, Nevada City, California
St. Helena's Episcopal Church, Beaufort, South Carolina
St. Louise Cemetery, New Orleans, Louisiana
St. Philips Church Cemetery, Charleston, South Carolina
Village Burying Ground, Bar Harbor, Maine

CONTENTS

Introduction	5
Graveyard Art & Symbolism	7
Unusual Tombs & Monuments	69
The Stone Carvers	90
Grave Study Considerations	95
Bibliography	102
About the Author	105

INTRODUCTION

W.T. Vincent, president of the Woolwich District Antiquarian Society wrote "these gravestones belong to the past and are hastening to decay. In one or two centuries none will survive unless they be in Museums. To preserve the counterfeit presentment of some which remain seems a duty." [1] Mr. Vincent wrote these words in 1896 but they are as valid today as they were then.

Gravestone studies are a popular past time today with many people photographing them and taking rubbings. Vandals continue to destroy gravestones at an alarming rate and even though they are often set upright again any physical damage is rarely repaired to its original state.

Vandalism not only destroys a form of artistic expression but also destroys links between our time and society and the past, our cultural history and our ties to humanity. The history of our nation, of all nations, can be read in grave markers and it is this personal link between us and the past that is endangered.

This book is written to preserve many of these sites at least in word and photograph so that even if the actual

[1] Vincent, W. T. *In Search of Gravestones Old and Curious.* London: Mitchell & Hughes 1896,

markers are no more we will have a memory of them, what they represented, who they were created for and a bit about the story of the individual who lies buried there.

There are other books on graveyard symbolism, stone cutters and historic cemeteries which is a good thing for there are thousands of cemeteries with millions of gravestones that need to be recorded to preserve the symbols so skillfully rendered by the stone cutter.

Included in this book are a few suggestions on how to accomplish gravestone rubbings and other gravestone study considerations.

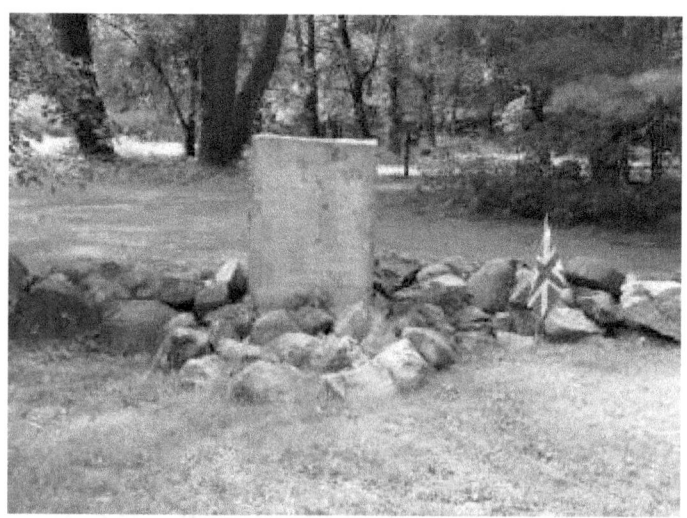

Grave of British soldier killed at the battle of Lexington during the first salvos of the Revolutionary War.

GRAVEYARD ART & SYMBOLISM

Perhaps some of our most mysterious, impressive and artistic symbolism can be found in our cemeteries. Ancient pagan, classical Greek and Roman, and the eternal symbols of hope, love and despair appear in many of our older places of rest. Unfortunately, although gravestones continue to be produced the rising costs and cemetery regulations many have been replaced by the flat, two-dimensional and plain metal plate. The ancient and mystical representations are becoming harder to find.

Researcher Douglas Keister noted that the majority of American cemetery architectural motifs can be divided into six categories:

1. Ancient pagan architecture
2. Egyptian architecture
3. Classical architecture
4. Gothic architecture
5. Late nineteenth and early twentieth century architecture, and
6. "Uniquely funerary architecture." [2]

[2] Keister, Douglas. *Stories in Stone: A Field Guide to Cemetery Symbolism and Iconography.* New York: MJF Books 2004, 13.

Late nineteenth and early twentieth century architectural styles include Art Nouveau, Art Deco and modern classicism.

Many of the symbols we find in cemeteries are representative of the many secret societies that exist in the United States, such as the Freemasons. The Freemasons utilized many of the pagan symbols for their rituals and iconography. These were freely left as well on headstones and tombs.

Symbolism is a wonderful thing. Images and symbols evoke feelings of wonder, awe, fear, joy, sadness and all of the complex emotions that make us human. The symbols on these gravestones tell a history through the carvers art of the individual buried under the stone as well as the time he or she lived in.

Humankind has marked the graves of its loved ones for hundreds of thousands of years. In many examples they were marked by upright stones, stone circles, dolmen or complex burial chambers. In others, images of beasts and monsters or the symbols of metaphor adorned the stone markers—and these have carried over into contemporary times. That is until very recently. Due to cemetery regulations, costs and the lack of the stonemason's talent has reduced our markers

to a purpose that is more utilitarian than loving pieces of art hand carved for the mourning family.

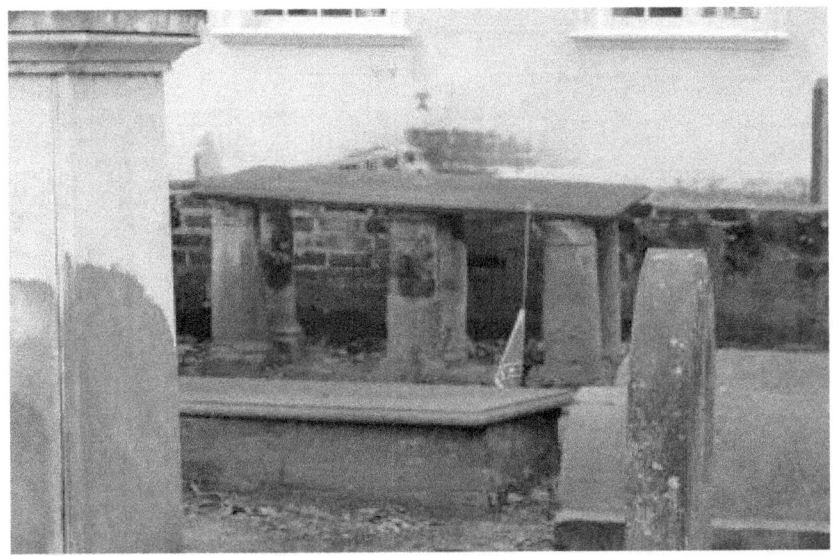

The photo above shows a continuation of the ancient dolmen burial into the 18th century. This is a very rare grave marker, the only one of its kind I have seen in the United States which dates to "modern times." There are similar tombs on the east coast however to be found.

Like those anonymous sculptures of the gargoyle and grotesque, the craftsmen that created these exquisite carvings on old headstones utilized both approved religious themes and those of an ancient pagan past. "Much of the sculpture's work," wrote Potok, "is startling in its mastery; some of it goes beyond craft into the subtler realm of art. Variation and

prodigality of symbolism and decoration abound, as if they were entirely without fear of condemnation for idolatry." [3]

However, what about those strange carvings of dragons and other mythical beasts that are found on tombstones around the world and among diverse cultures of differing religions? "Dragons, monkeys and griffins," writes Chaim Potok on images found in Jewish cemeteries, "seemed to emanate from some primal apocalyptic bestiary." [4] Dragons have long been equated with the Devil in Christian lore, the supreme leader of the enemies of God. In other lands, however, the dragon "represents the highest spiritual power, strength, and supernatural wisdom." [5] It is not uncommon for various symbolic representations to have the most opposite of meanings between cultures. Christianity is expected to find evil and the Devil in symbols that were, and still are, important among cultures of other faiths and ages as positive images.

St. John used the dragon, as a representation of Satan, in the New Testament chapter of Revelation: "And the great dragon was cast out, that old serpent, called the Devil, and

[3] Potok, Chaim. "Forword" in *Graven Images: Graphic Motifs of the Jewish Gravestone* by Arnold Schwartzman. New York: Harry N. Abrams, Inc. 1993, 14
[4] Potok, op cit., 13.
[5] Keister, op cit, 93

Satan, which deceiveth the whole world: he was cast out into the earth, and his angles were cast out with him." [6]

The dragon depicted in the photo below most likely represents the defeat of Satan by the church and thereby, as viewed by Christianity at the time, paganism.

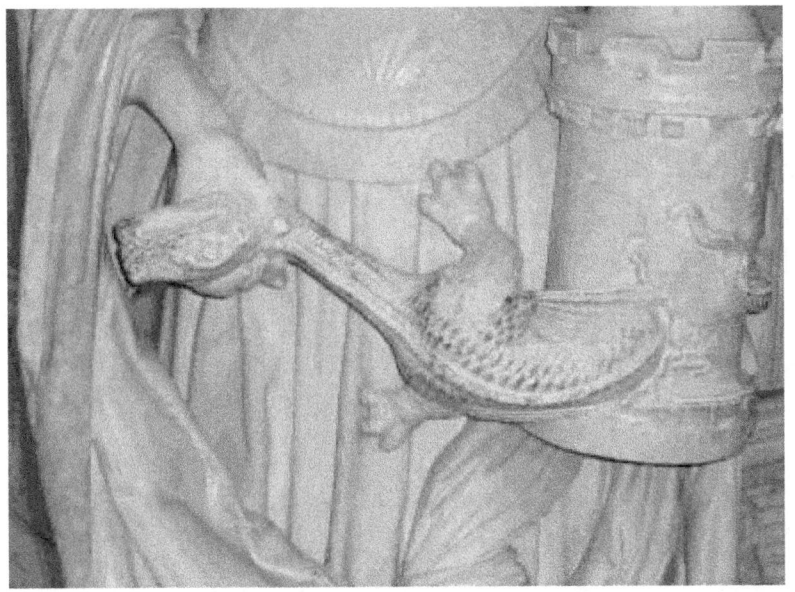

Details from tomb of Francis II, last Duke of Brittany, ca. 1502 CE. Cathedral of St. Pierre, Nantes.

Griffins too suffer from this duality of meaning. Griffins have appeared in ancient art from Babylon to Greece, Rome and the Orient as a symbol of the sun and the guardian of

[6] Revelation 12:9, King James Version

treasures. The griffin symbolized dominion over the land and the sky and was used symbolically as a sign of power. In the East, the Griffin was symbolic of wisdom and enlightenment—just as the dragon. But, alas, in Christian tradition the griffin depicts evil. The image was used as a symbol of Satan flying away with the souls of those who persecute Christians, or, as Evans relates, demons that "flew aloft on the pinions of pride and fell from heaven into the abyss of hell for their misdeeds."[7]

Sometime in the 14th century, the griffin became a symbol of the dual nature of Christ rather than the evil of Satan. As is often the case with Christian symbolism, the griffin in its aspect as master of the heavens and the earth was absorbed in Christian iconography and eventually symbolized the Pope as head of spiritual and temporal power.

One of the most common symbols in 16th and 17th century graveyards in the United States is the skull, also referred to as a "deaths head". The skull is the most literal symbol of death. During the 16th and early 17th century Puritan influence dominated society and gravestones became extremely dark and foreboding in their message. Many markers were adorned with grim skulls and often the wording "Here lies buried the body of…" indicating that the

[7] Evans, E. P. *Animal Symbolism in Ecclesiastical Architecture.* London: W. Heinemann 1896, 39.

individual lived and died with nothing important between or after. The death head symbol is one the earliest gravestone designs in the colonial United States.

The deaths head figure is not found west of the Atlantic coastal and southeastern states.

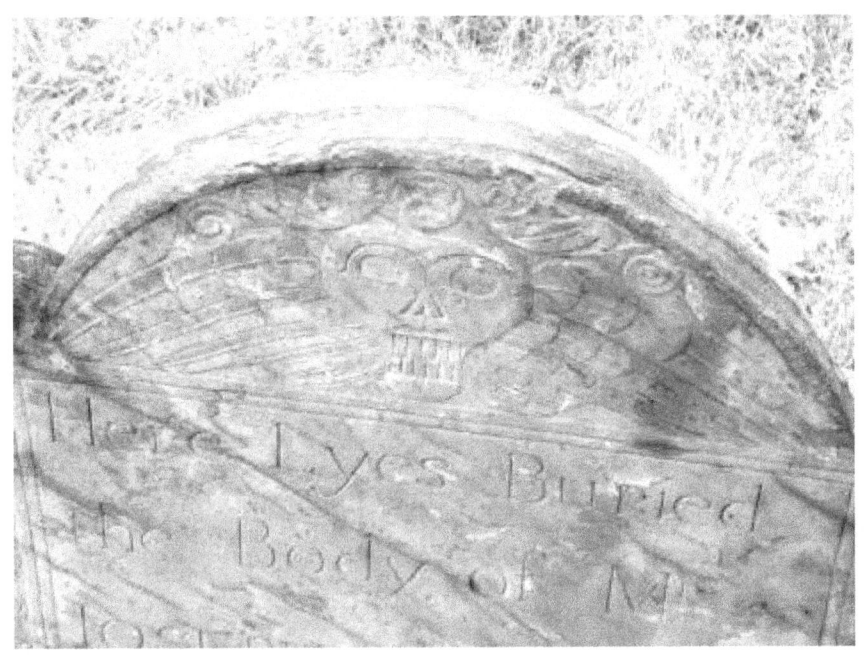

After Puritan influence began to wane in the mid-1700's the markers still depicted skulls, but skulls associated with a brighter and more innocent image. (Note the small rosette located above the winged face in this stone dated 1713. (The rosette symbolizes messianic hope, promise and love.)

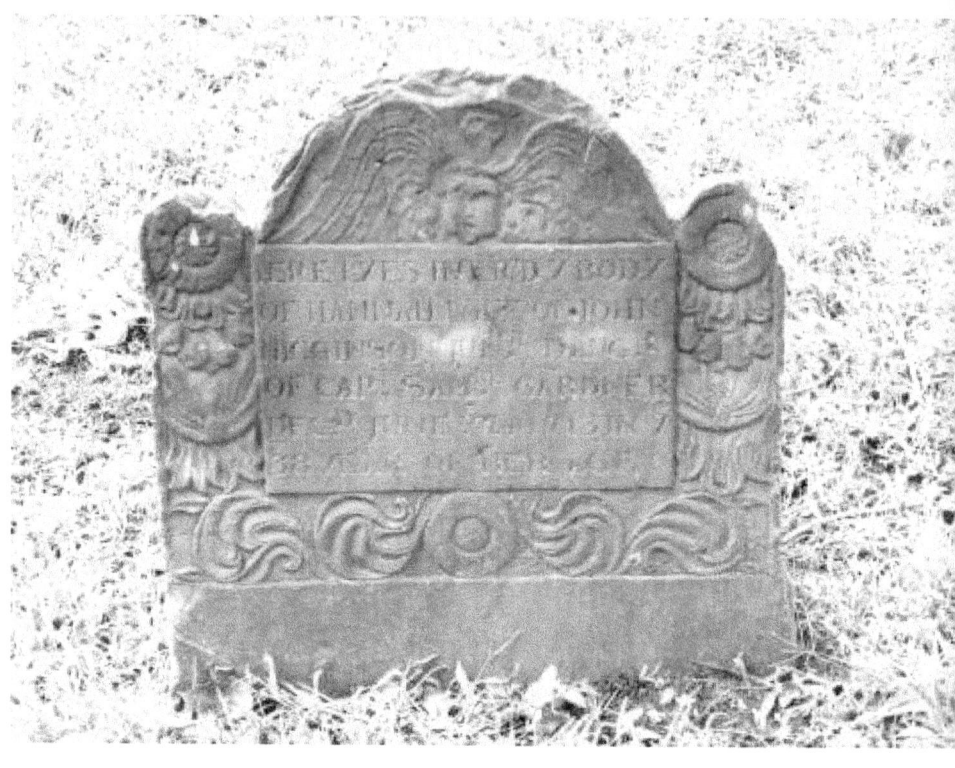

 The two rosettes shown on this stone are representative of messianic hope, promise, and love. Obviously, the meticulous designs of this stone were carved for a person of means and someone of social import.

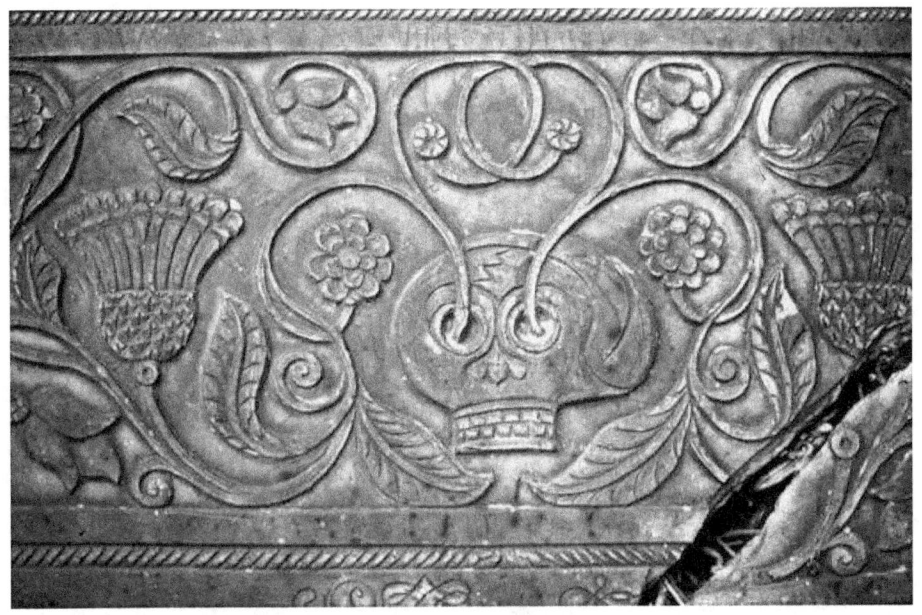

Public domain Photo by Simon Garbutt of a gravestone at Shebbear in Devon, England.

The photo above is an elaborately carved representation of a skull with vines growing from the eye sockets reflecting the soul's resurrection and life's regeneration after death.

In the United States the deaths head is one of the earliest expressions of gravestone art and simply reflects the ultimate symbol of death.

Other unusual symbols of death which almost defy explanation are found at times as well. The following photograph taken in a California cemetery seems to show a

large bird-like creature holding a scythe and a young woman. The broken column represents a life cut short too soon and early grief. It is also used to represent the loss of the head of the family. Of course, the scythe symbolizes Death's harvest. The laurel held by the woman represents triumphant victory.

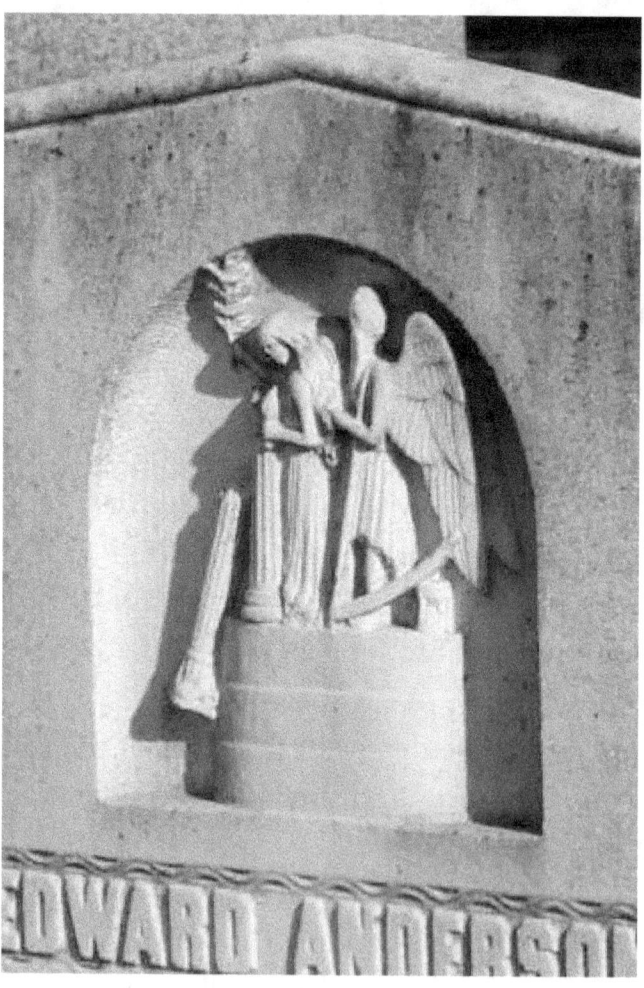

Death escorting a woman to the Other World.

Other symbols of death are not nearly as strange, such as the winged angel of death shown below.

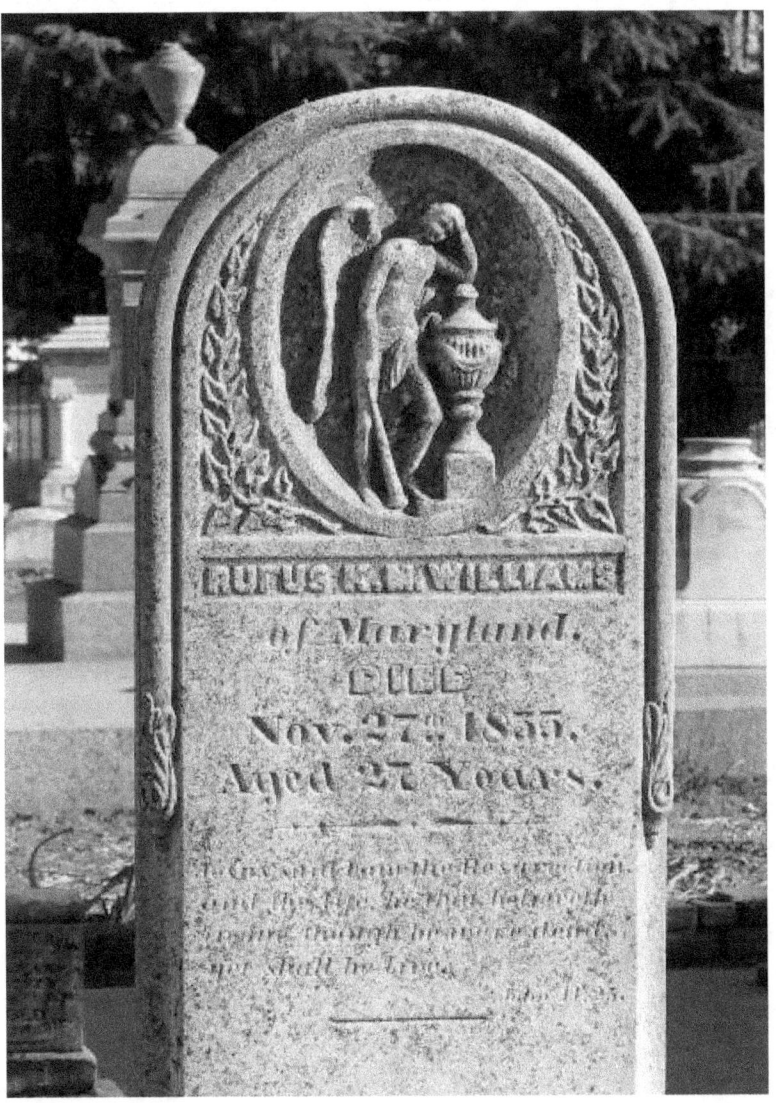

While many gravestones reflect social and financial success there are some still surviving the elements which belong to persons of much more common status. The one below is a simple stone with the letters J and H, the only identifying marks with a simple symbol of a tree or star. We cannot know who this person was or his place in 18th century society.

A very simple marker above contrasted with a more ornate and stylish stone below of a man and wife.

The double headstone for a man and wife above is interesting as the woman has a life-like image engraved on her stone while her husband has the winged face representing his flight to heaven.

More pleasing stones with likenesses of the deceased engraved were created as well. The stone shown at the next page is that of a 20 year old man and it is refreshing in its simplicity, straight lines and attention to detail. The vines growing up the side add a touch of decorative flourish.

Most portraits such as this were done in the abstract and were not meant to be accurate likenesses.

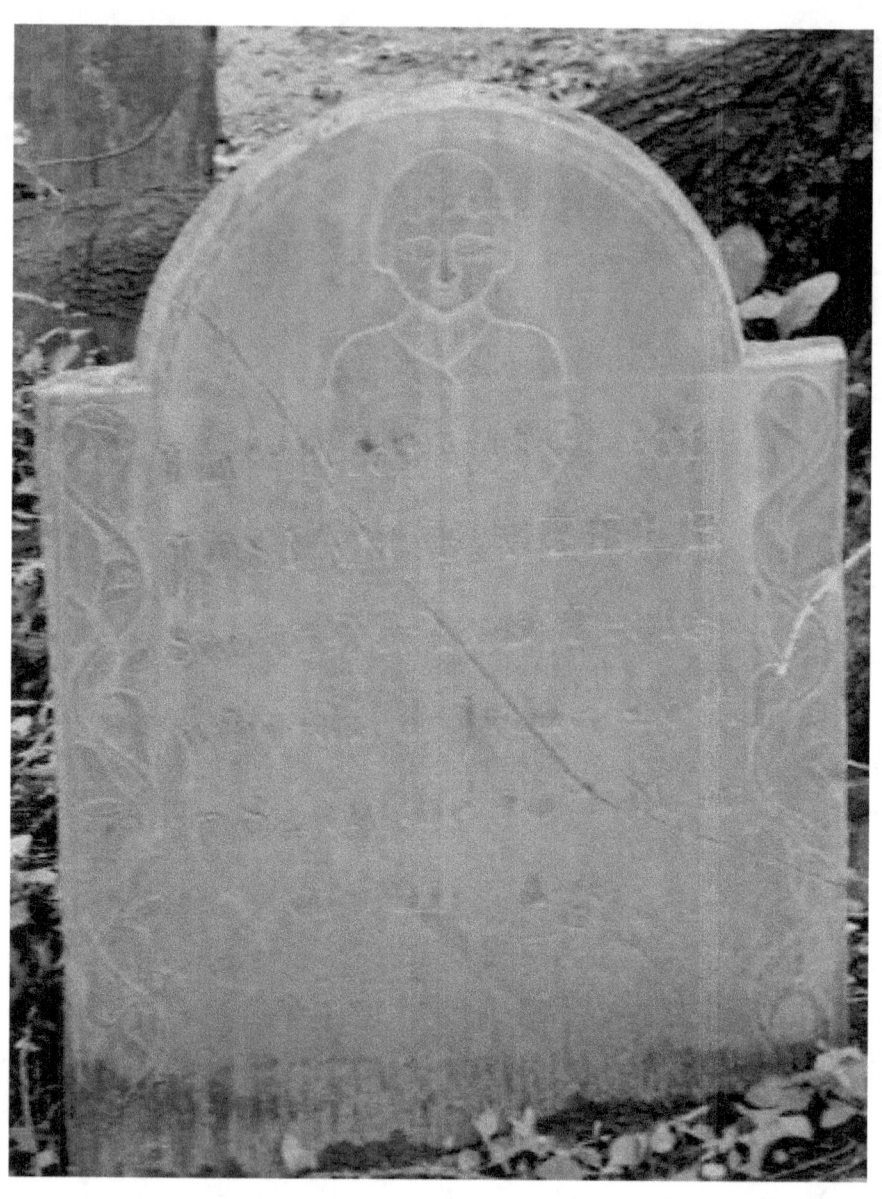

By the nineteenth and twentieth centuries portraits did become more lifelike but were usually only found on expensive monuments like the example below from California.

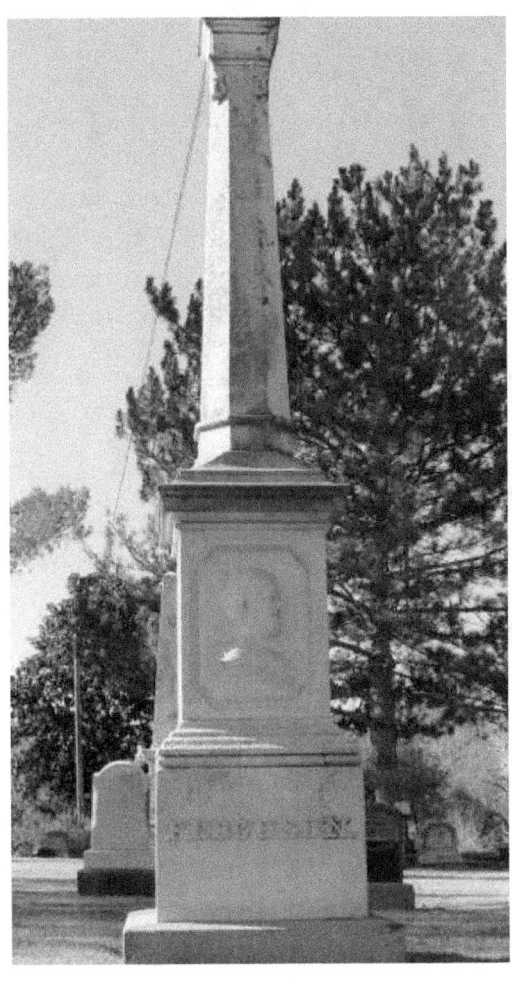

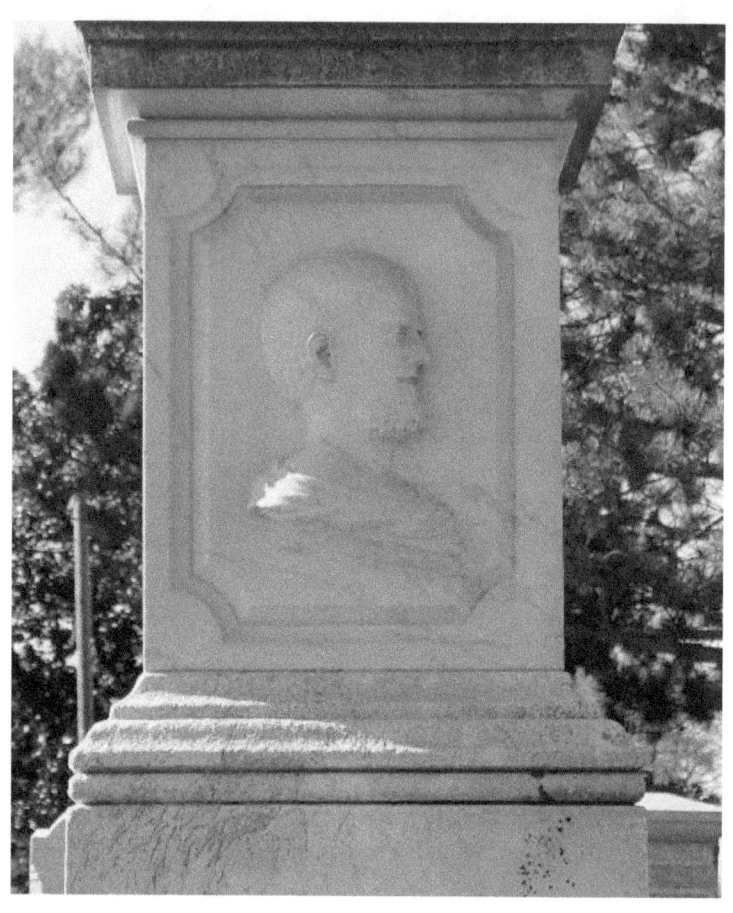

A fine example of the winged face motif representing the soul in flight, is this grave stone below located in Salem, Massachusetts.

The winged head as shown below marked a stylistic change after the Puritan domination of religion lessened and eventually these images changed again into angels.

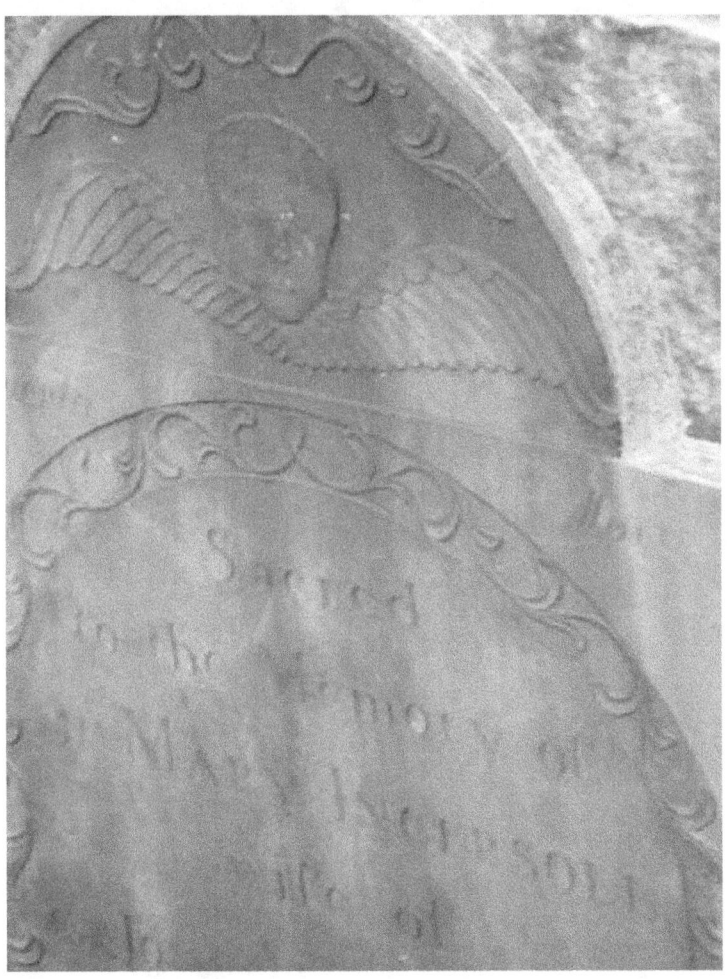

Many of the symbols found on burial markers have even more obscure meanings and origins. Hands are one of the most common images found in pre-twentieth century cemeteries.

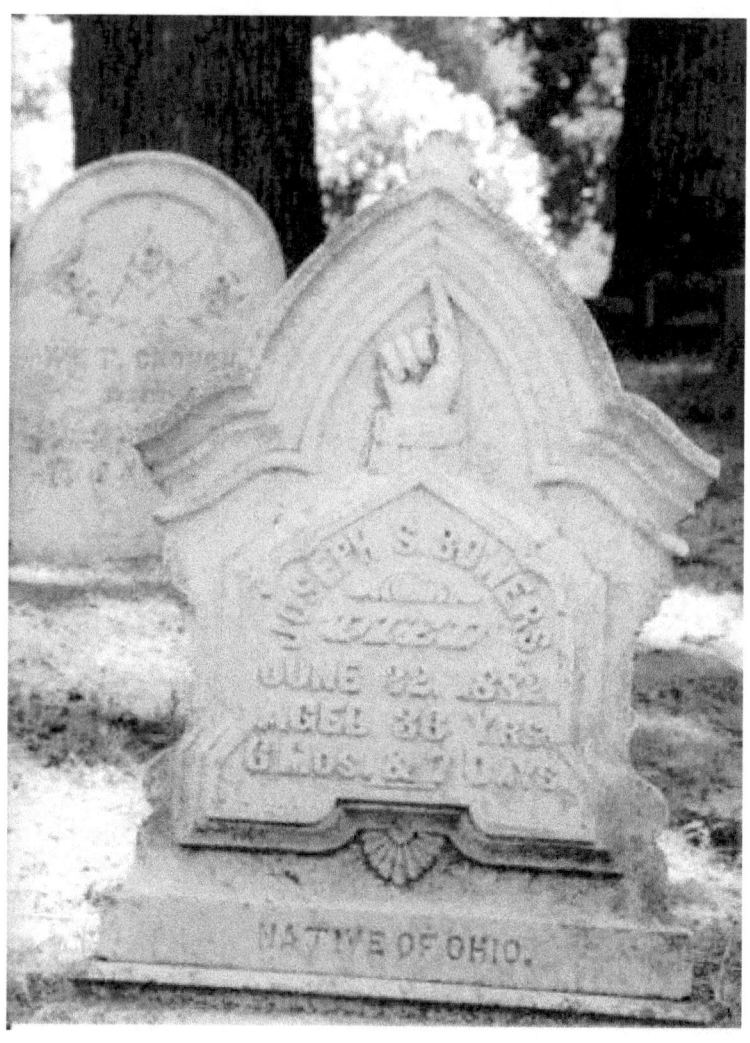

The hand pointing up acts as a road sign, telling visitors to this grave that the occupant no longer resides on the earth but has gone onward to heaven. This style was common during the 1860s through 1880s.

The image shown above appears in graveyards from California to Virginia. While hand images are common elsewhere, a hand pointing up appears only in Christian cemeteries.

A similar symbol is a hand with the index finger pointing down which represents God reaching down for the soul. The wreath carved under the hand is representative of victory.

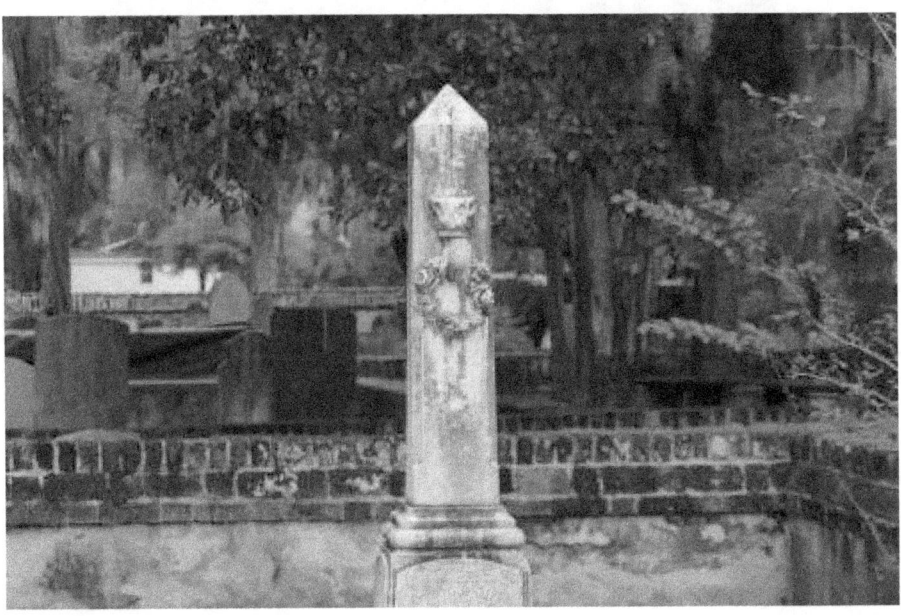

Hands carved on Jewish headstones are shown with the fingers separated "to form openings through which the blessed Shekhinah (radiance of God) streams down upon the congregants." [8]

Other hand motifs include hands that appear to be shaking. This normally represents matrimony if the sleeves shown appear to be masculine and feminine. If the sleeves are gender neutral the image may be that of a heavenly welcome or an earthly farewell. In Chinese symbolism, clasped hands represent friendliness and allegiance.

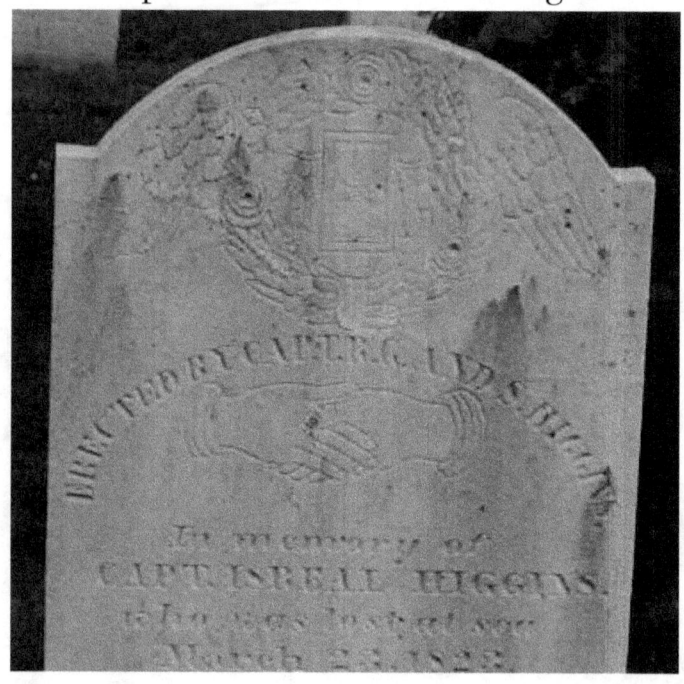

[8] Schwartzman, Arnold. *Graven Images: Graphic Motifs of the Jewish Grave Stone.* New York: Harry N. Abrams, Inc. 1993, 22.

Hands together often symbolize matrimony. The stone above was erected at Bar Harbor, Maine for Capt. Isreal Higgins who was lost at sea on March 23, 1823.

Two hands clasped with a cross. Stone dated 1903, Marysville Cemetery, Marysville, California.

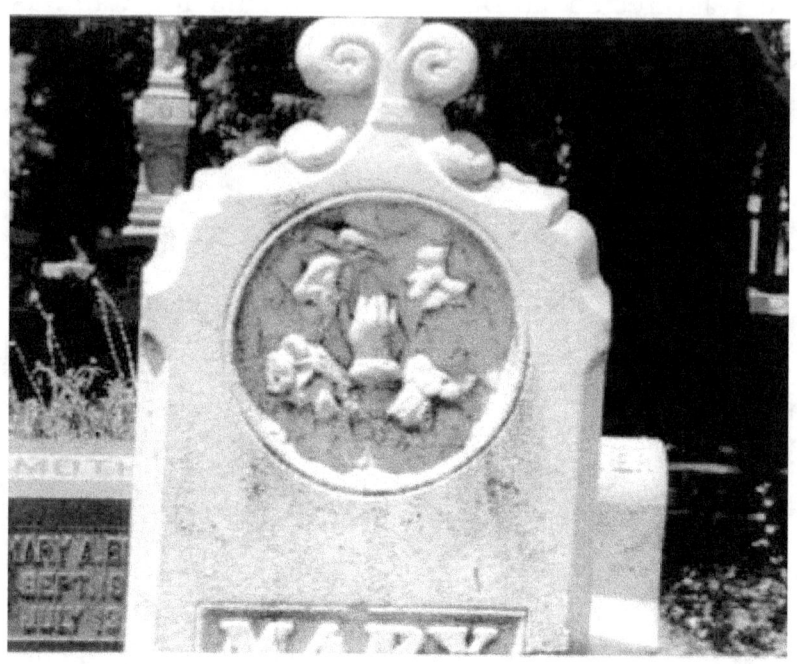

In Christian symbolism, hands appearing in the midst of clouds represent the power and presence of God.

The dove is an appropriate symbol for burial markers as it also represents "the passing from one state or world to another." [9] Perhaps the most common animal figure used in cemeteries, the dove is most frequently depicted as holding an olive branch in its beak. The meaning, of course, refers to the flood myth and the dove that Noah released which

[9] Cooper, J.C. *An Illustrated Encyclopaedia of Traditional Symbols.* London: Thames and Hudson 1978, 54.

returned with an olive branch signifying that the flood waters had receded from the earth. The dove also signifies purity and peace. The symbol of the dove with an olive branch is universally representative of peace.

Across time, the sacred dove has been associated with funerary cults and was sacred to all Mother Goddesses, depicting femininity and maternity.

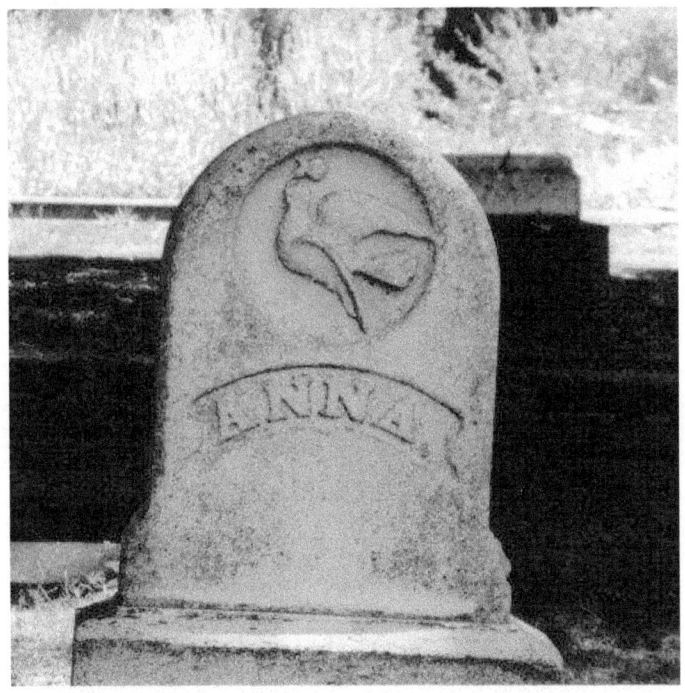

The dove of purity and peace.

A double-headed dove, much like the double-headed eagle, signifies the dual nature of unity. The double-headed dove shown below appears to be part of an older Masonic

emblem which time has effectively erased. This symbol represents the dual nature of unity and is also an imperial emblem of power and protection. According to the Association for Gravestone Studies, it also symbolizes a 32nd or 33rd degree Mason. [10]

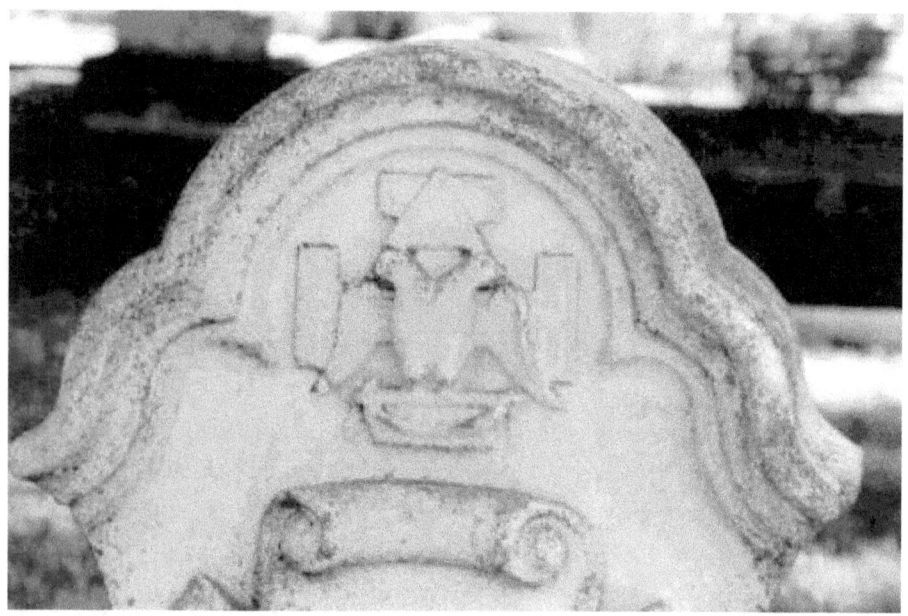

Double-headed dove representing the dual nature of unity and protection.

Descending doves are common gravestone motifs and when shown with an olive sprig it represents hope and promise. The stone shown on the next page is an unusual

[10] *AGS Field Guide No. 8: Symbolism in the Carvings on Gravestones.* Greenfield: The Association for Gravestone Studies (AGS) 2003, 5.

depiction of a woman and two growing children with two descending doves, each with an olive sprig.

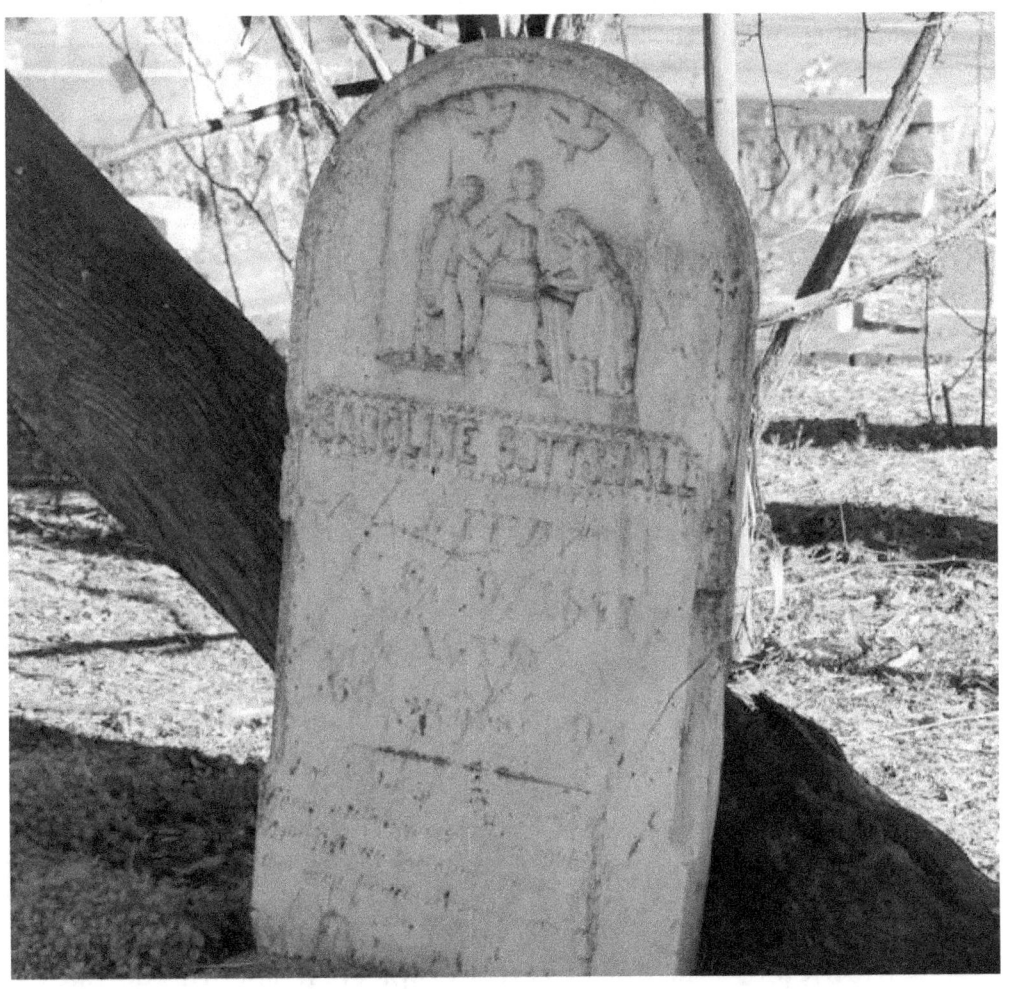

Other common symbolic motifs on grave markers include various forms of vegetation—both mythical forms and common species. As unlikely as it may seem, a sheaf of

wheat is a popular Masonic symbol and is used on grave markers to indicate "someone who has lived a long and fruitful life of more than seventy years." [11] Other interpretations include the "divine harvest at life's end" and a life fulfilled. [12]

A sheaf of wheat on a headstone denotes a long and fruitful life.

Wheat is symbolic of immortality and resurrection. Being a staple of life, wheat has been thought of as being a gift from God. Like other cereal crops such as corn and barley, wheat symbolizes the fertility of the earth, renewal, rebirth

[11] Keister, op cit., 60.
[12] AGS, op cit., 7.

and abundance. In Christian symbolism, wheat represents the body of Christ, the righteous and the godly.

Flowers are often found in cemeteries not only as fresh offerings to departed members of the family or to friends but as carved images on headstones. Flowers are important symbols in many cultures, representing gods and goddesses, the soul and the spiritual flowering of the spirit, immortality and the brevity of life, and of course, rebirth. During the Festival of Rosalia in ancient Rome, roses were scattered over graves.

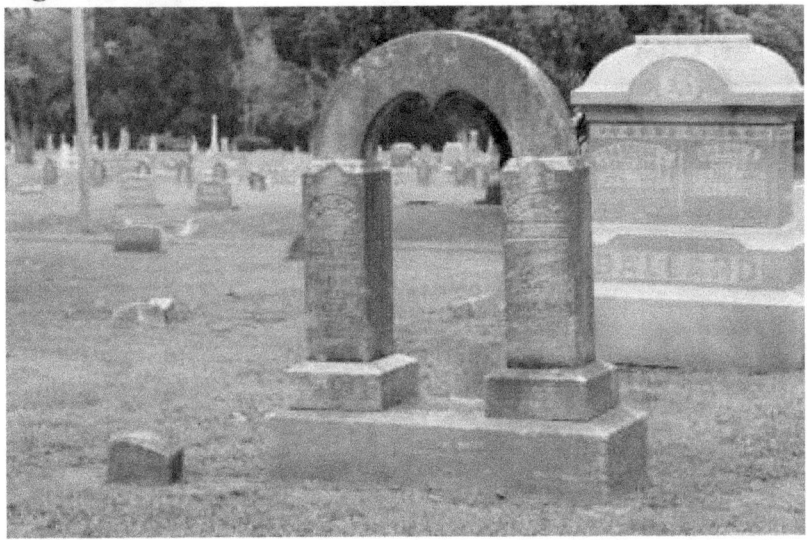

Stylized 19th century arch marker. Often the arch reflected the vault of heaven.

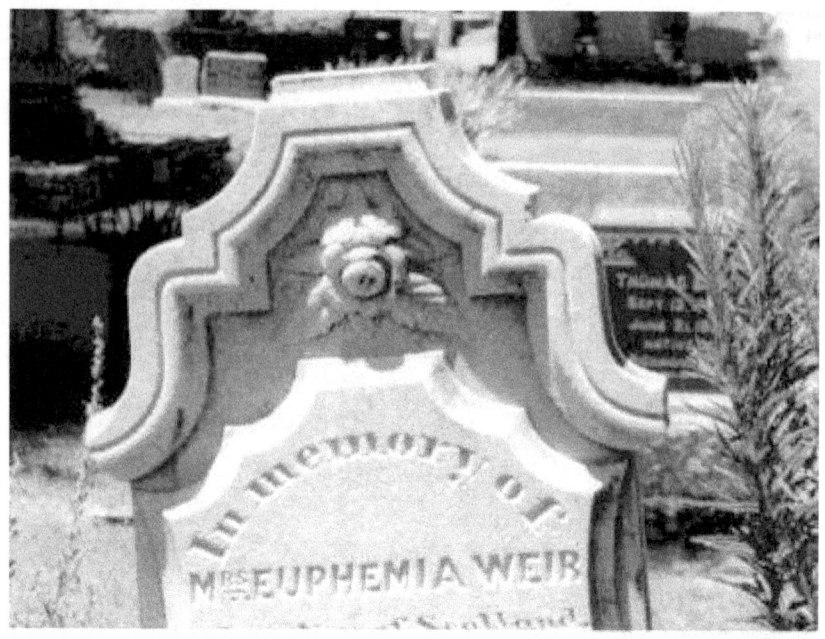

The rose, as carved on this headstone, commonly adorned the graves of Victorian women.

The rose has, as many symbols do, a dual nature. It has represented "heavily perfection as well as earthly passion."[13] It also symbolizes both life and death, immortality and the limits of Time. As used in association with funeral traditions, the rose symbolizes eternal life and resurrection. In Christian lore, the rose grows on the Tree of Life, signifying regeneration and eternal life.

How the rose is depicted on gravestones often reflected the age of the deceased. For example, a rose shown as just a

[13] Cooper, op cit.,141.

bud indicates a child of 12 years or younger, partial blooms represent a teenager and a rose in full bloom is that of someone in their early to mid twenties or older.

Many grave markers are indicative of the profession of the deceased. The ship usually marks the grave of a ships captain or someone who has led a seafaring life although it is also a Christian symbol representing the church ferrying the faithful through the world.

The mast and anchor are considered in Christian symbolism to be the cross in disguise and were used to

symbolize hope. The photos below and on the following page were taken at the Village Burying Ground in Bar Harbor, Maine where numerous sailors lost at sea or killed in sailing accidents and battles are remembered. The anchor is commonly found in United States burial grounds coast to coast.

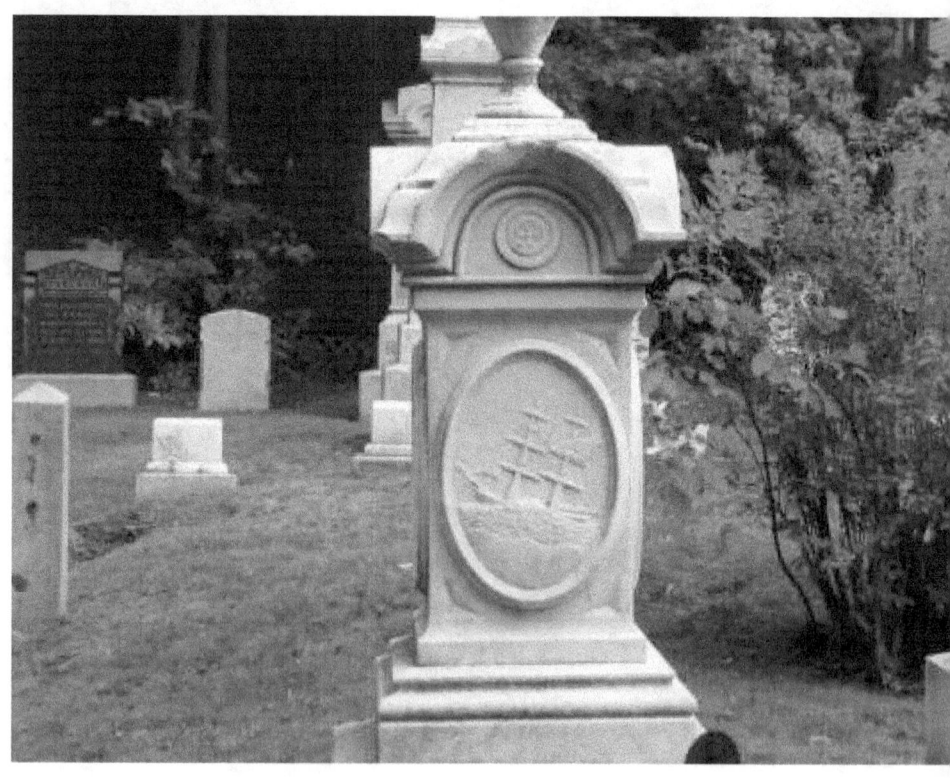

Seaman's burial, Bar Harbor, Maine.

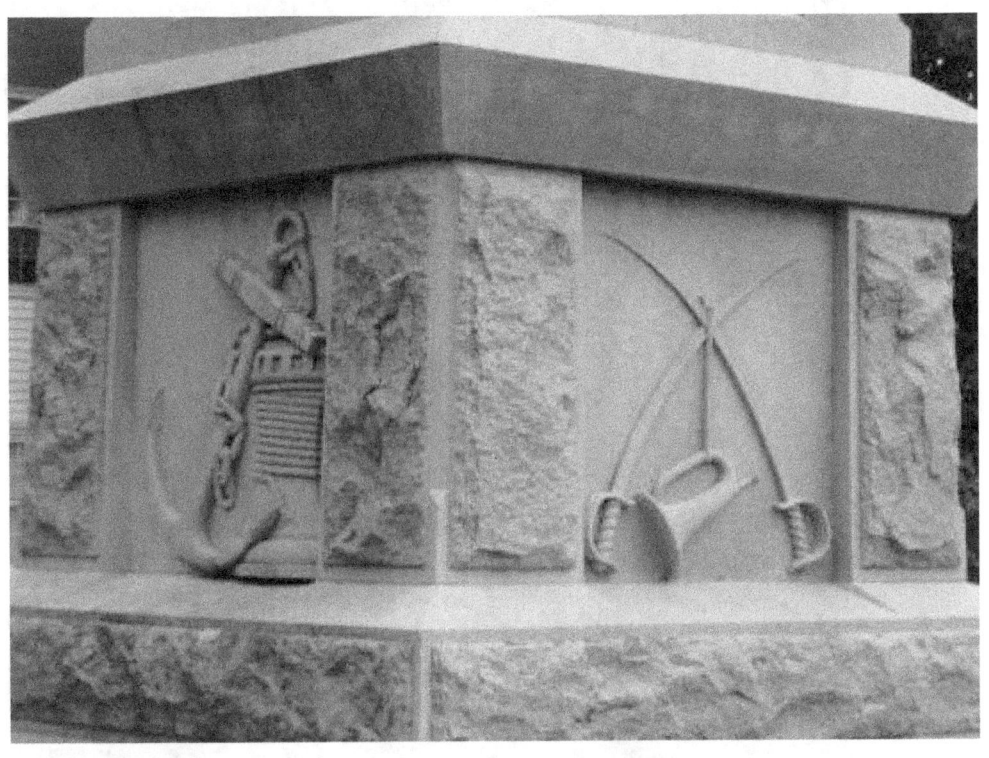

Two typical sea-themed tombs, Bar Harbor, Maine (above) and Sacramento, California (next page).

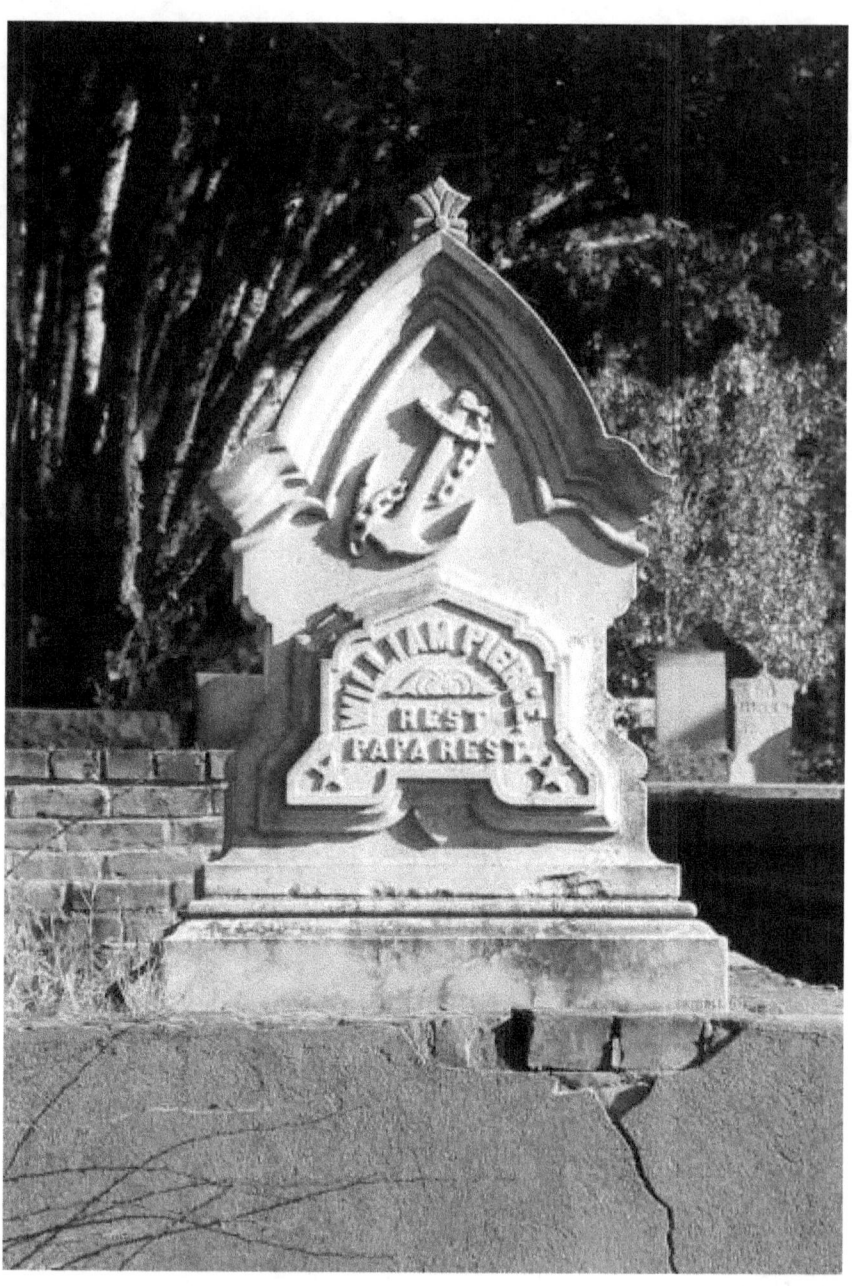

A popular funeral flower of the Victorian Age is the lily. The lily represents chastity, innocence, purity, light, perfection and mercy among other lofty ideals. Specifically, the lily on gravestones represents the restored innocence of the soul at death. The lily is associated almost exclusively to the Virgin Mary.

The lily symbolizing purity and restored innocence,

The palm tree is rather rare as a graveyard symbol but they do occur as shown below. In the Mediterranean the palm was long regarded as sacred with the sun god Assure often depicted above the palm. The ancient Egyptians, Romans and Christians were fond of the palm as representative signs of victory both in war and over death. It also represented rebirth.

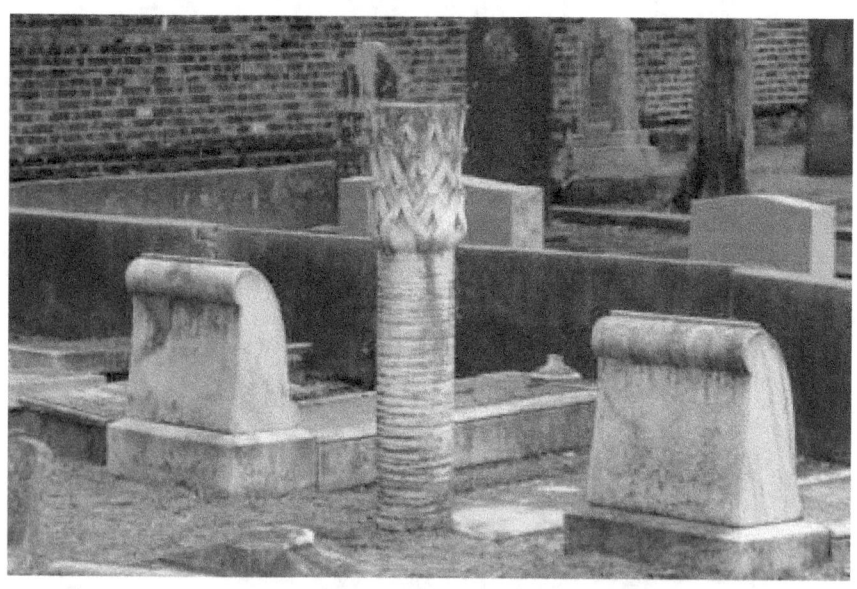

I recently visited a 300 year old graveyard associated with St. Helena's Episcopal Church in Beaufort, South Carolina. Originally established in 1712, the graveyard contains the remains of British troops killed when they attempted to take nearby Port Royal in the Revolutionary War, Civil War dead from the Battle of Port Royal and those who died in all the

other 300 years of its existence. One grave is that of Capt. Paul Hamilton (below) who at his death at 20 years of age had participated in 80 Civil War battles for the Confederate States.

His marker not only has a palm tree carving representing victory over death, but pilgrims continue to leave scalloped shells at the foot of his marker as offerings to represent his journey through death and rebirth.

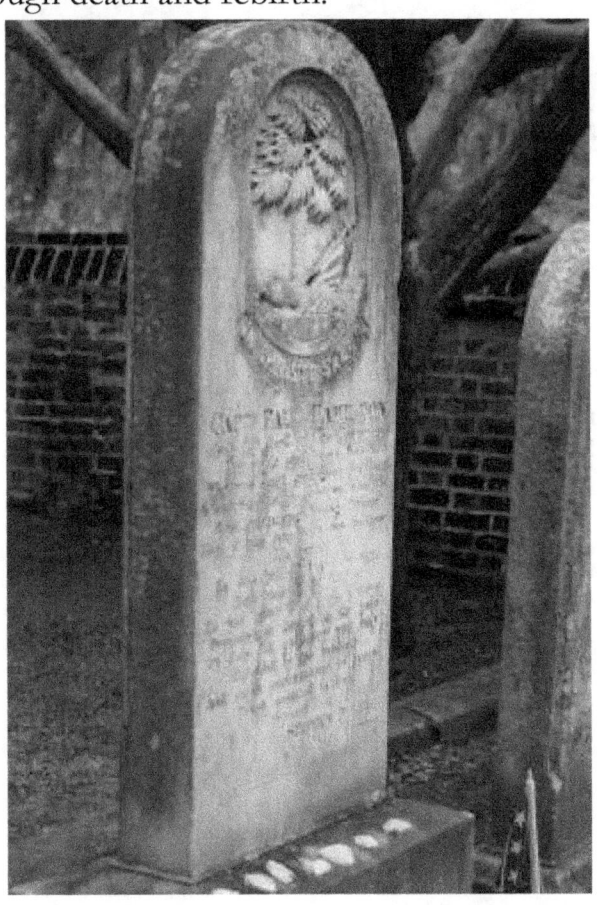

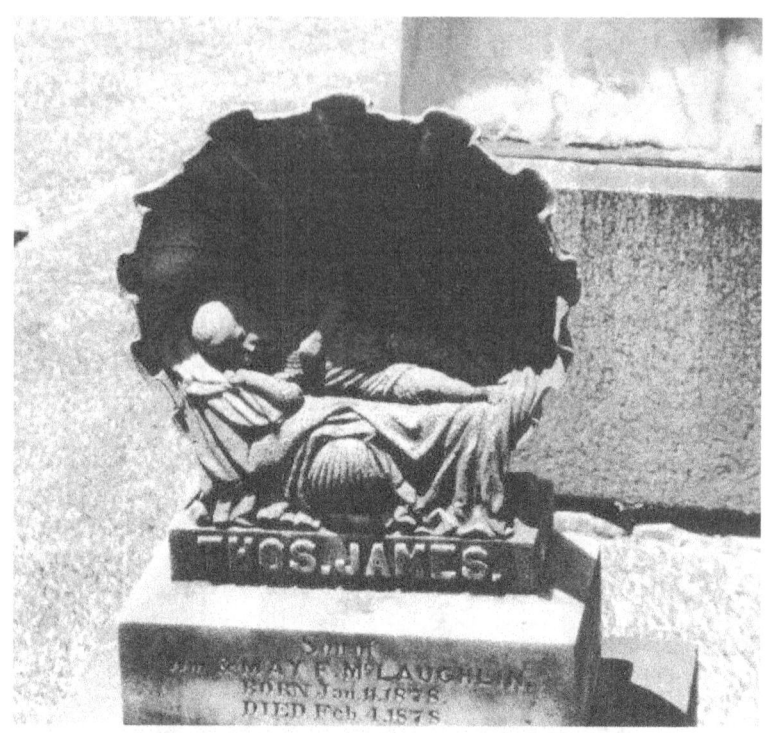

The shell represents a journey and regeneration or rebirth. This grave marker of an infant is a touching reminder of the journey we all take.

The shell is one of the more unusual graveyard decorations. The scallop shell is the most usual of this motif. Symbolically, the shell represents a pilgrimage or journey however it has also been used to symbolize baptism and fertility. According to Jack Tresidder, the shell is a symbol of the vulva, "linked with conception, regeneration, baptism,

and, in many traditions, prosperity—probably through its association with fecundity." [14]

The scallop also represents birth, resurrection and everlasting life.

During the Victorian age, and its associated neo-pagan revivalist era, other interesting pieces of symbolic art found themselves incorporated in cemeteries as well as on secular architecture.

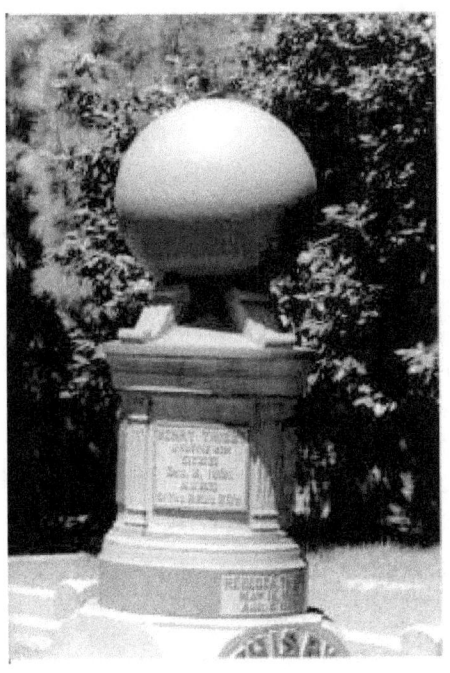

[14] Tresidder, Jack. *Symbols and Their Meanings.* New York: Barnes & Noble 2006, 13.

Purely decorative or does this stone ball shown above represent something more ethereal? Keister wrote that stone balls in cemeteries are "almost always purely decorative." [15] A cluster of three such stone balls, however, connotes a gift or money. However, there are other meanings behind this symbol as well. Cooper notes that balls may represent either the sun or the moon and symbolic of the power of the gods to hurl comets from the heavens. [16] Carved stone balls have appeared in widely diverse areas of the world and apparently represent mystic and archaic meanings. According to the Association for Gravestone Studies, these balls may represent the endlessness of time, or eternity, which would be very appropriate for cemetery symbolism.

Orbs have also been linked to the reward of resurrection, faith and the above mentioned celestial bodies. In addition, being round the balls has no ending or beginning representing eternity.

In Mesoamerica, where the ballgame was played for ritual reasons and the results were often deadly, the ball itself symbolized the sun that not only journeyed across the sky but also in and out of the underworld. [17]

[15] Keister, op cit., 110.
[16] Cooper, op cit., 17.
[17] Miller, Mary and Karl Taube. *An Illustrated Dictionary of the Gods and Symbols of Ancient Mexico and the Maya.* London: Thames and Hudson 1993, 43.

Victorian influence also was responsible for the introduction of ancient Egyptian motifs into secular architecture and graveyard decoration. The "rebirth" of ancient architectural styles during the neo-pagan revivalist period resulted in some of the more interesting changes to American homes and buildings. The photograph below shows how this style also came to be used on the tombs of our wealthier citizenry, who, according to some researchers, did not know the ancient symbolic meaning the image but chose the design due to the popularity of anything Egyptian. The Egyptian sun disk became popular in the middle of the nineteenth century.

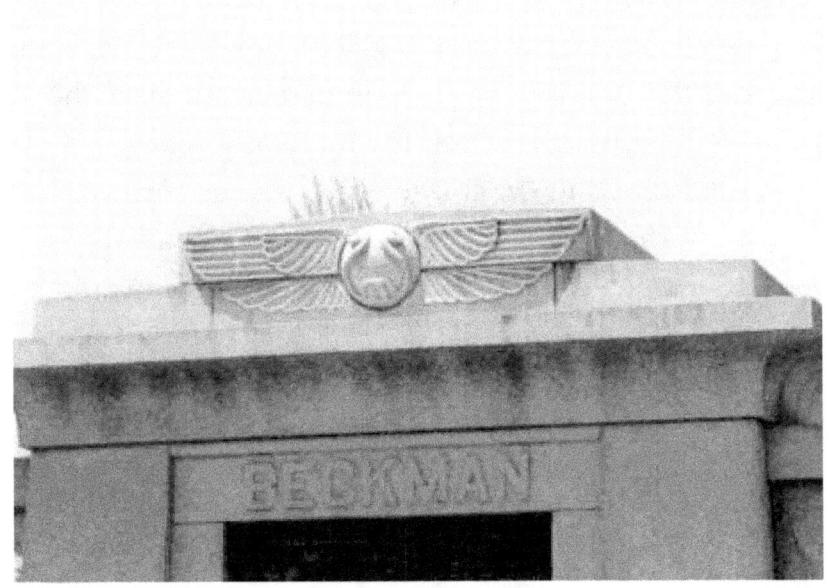

In ancient Egypt the winged sun-disk represented the solar power of Ra and Aton. In Victorian times it symbolized the renewal of life.

Many of the headstones found in our cemeteries also commonly show fraternal symbols. The Masons, also known as the Free Masons, have left their symbols throughout American burial grounds. The primary symbol used is that of the square and the compass, normally shown with a "G" inside the symbol. According to Keister, the square, or carpenter's square, and the compass represents the interaction between mind and matter, or rather "the progression from the material to the intellectual to the spiritual." [18] Biedermann elaborates on this, stating that the square, as it indicates a right angle, stands for what is right, justice and the true law. [19] The compass symbolizes the ideal circle of "all-embracing love" for humanity. The "G" which is centrally located in the image either stands for *Geometry* or *God*—or both. The exact meaning is clouded by the organizations reluctance to define their symbols and their meanings.

[18] Keister, op cit.,191.
[19] Biedermann, Hans. *Dictionary of Symbols: Cultural Icons & The Meanings Behind Them.* New York: Meridian 1994, 321.

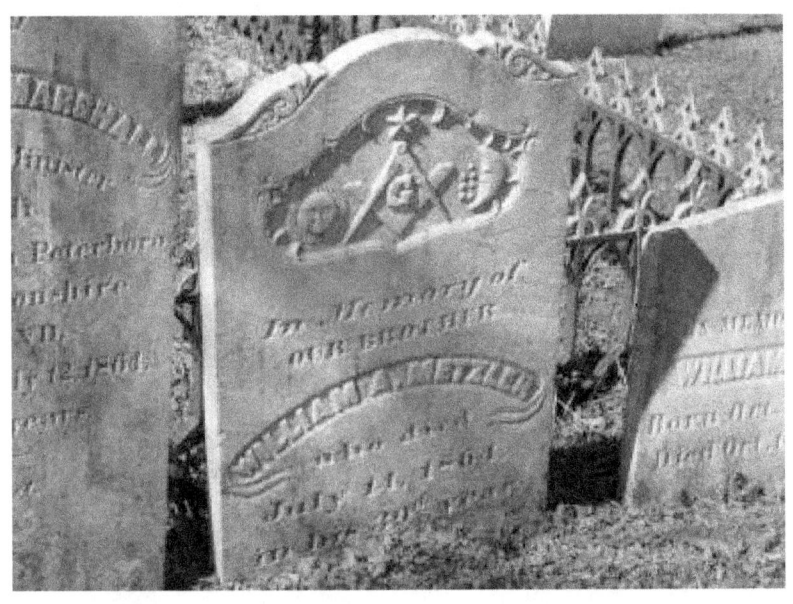

Masonic symbol on 19th century grave marker.

Gravestones belonging to the Masonic Order are very numerous in the United States and while many have the same symbols others are decidedly different. The one pictured above is unusual in that the sun and moon are important to the overall design. The sun and moon reflect the celestial kingdom of heaven and the afterlife.

One highly unusual, and mystical in appearance, (next page) is that of James B. Perry who died in 1896. The three link chain and unblinking eye set within several leaves is a one of a kind. This marker is located in Bodie, a California ghost town which was abandoned after the nearby gold mine became depleted.

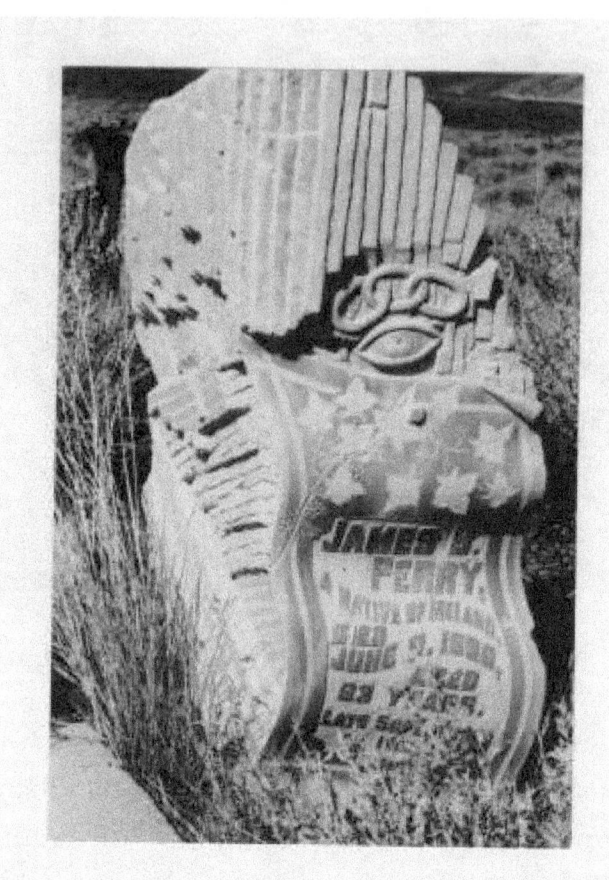

Photo by Brenna Varner

An unusual Masonic design below on this 1869 headstone has the basic Masonic elements of the compass and square overlaying an element of unknown origin and meaning.

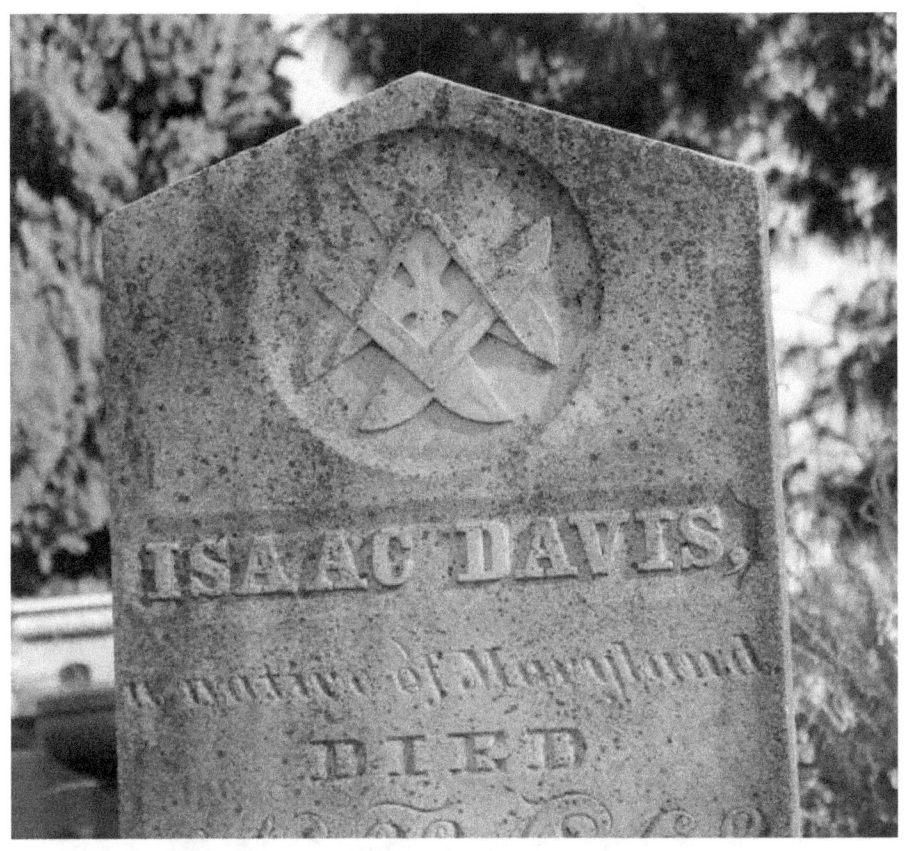

As previously noted, trees are also found in cemetery art—the symbolism is obvious—depending on the tree, they represent the Tree of Life, longevity, resurrection, eternity and incorruptibility. The beautiful carving in the photo below, of a Celtic style, may represent a stylized weeping willow which symbolizes grief and sorrow, or it may be, in fact, a form of the Tree of Life.

The weeping willow was one of the most popular images during the late eighteenth and early nineteenth century. In Christianity and other belief systems the weeping willow symbolized immortality due to the fact that no matter how many branches are cut off it continues to flourish.

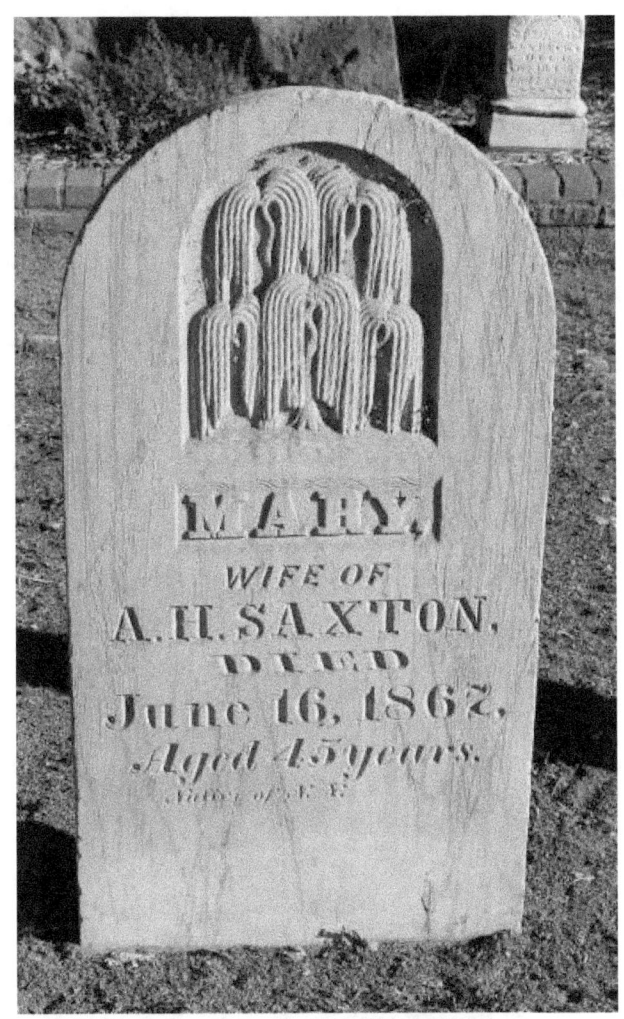

Classic weeping willow design.

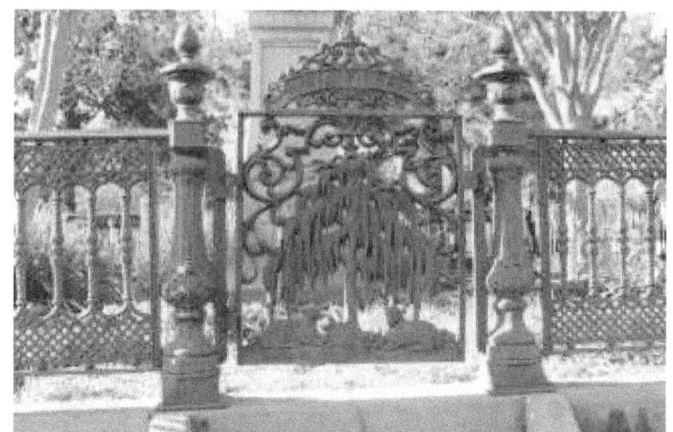

This beautiful gate decorates a burial in Sacramento with a willow tree.

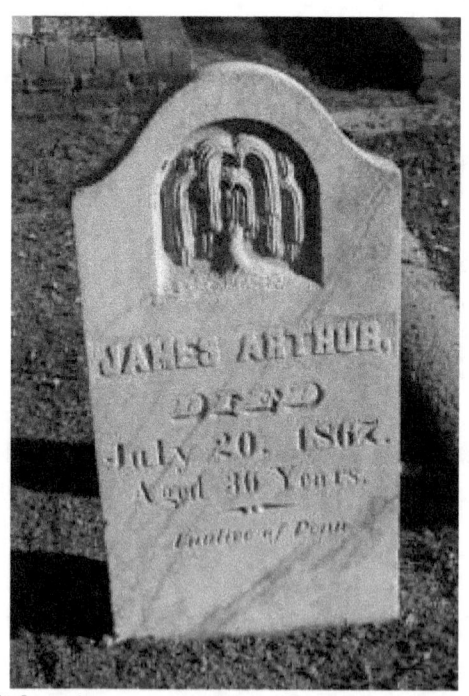

Another California gravestone decorated with a weeping willow.

Weeping willow gravestone showing signs of rubbing.

Other meaningful graveyard symbols include the obvious symbols of patriotism, loyalty and political association. The flag is perhaps the most meaningful and obvious symbol which not only identifies the deceased with his homeland

and participation in certain wars but with regional and philosophical values as well. National cemeteries are stark reminders of what we value and what we give up for those values.

The photos below illustrate those losses from both sides of a conflict as found in one South Carolina graveyard:

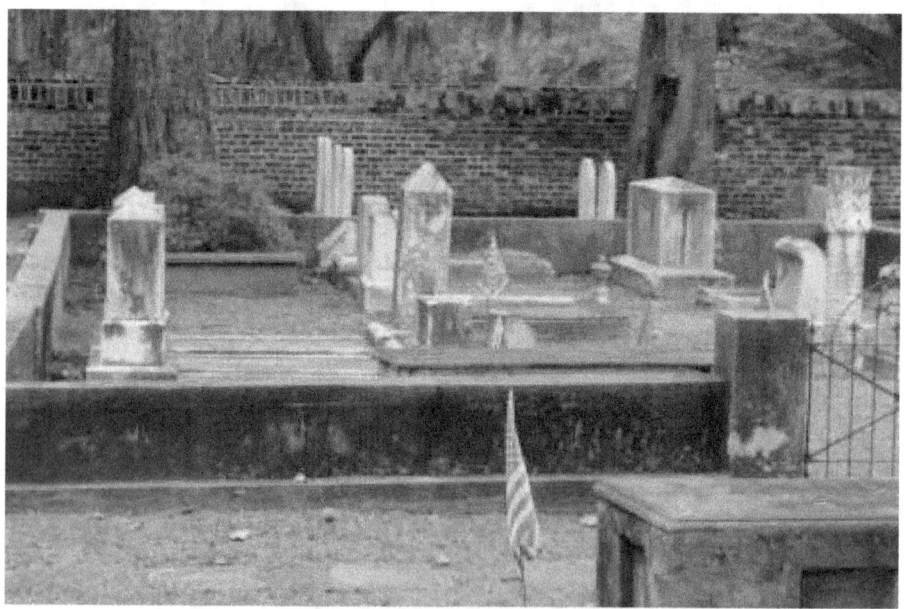

Weapons used in these conflicts also appear as graveyard images. The sword, as shown below, has several meanings including vitality and strength, association with the military and gods of war and as a symbol of indomitable power and divine truth.

The sword has often been associated with magical powers and supernatural properties—especially during it history as the weapon of choice in battle. An oath sworn on the sword was as binding as one sworn on the Bible. A sword inverted, as the one shown below, represented victory as well as the relinquishment of power.

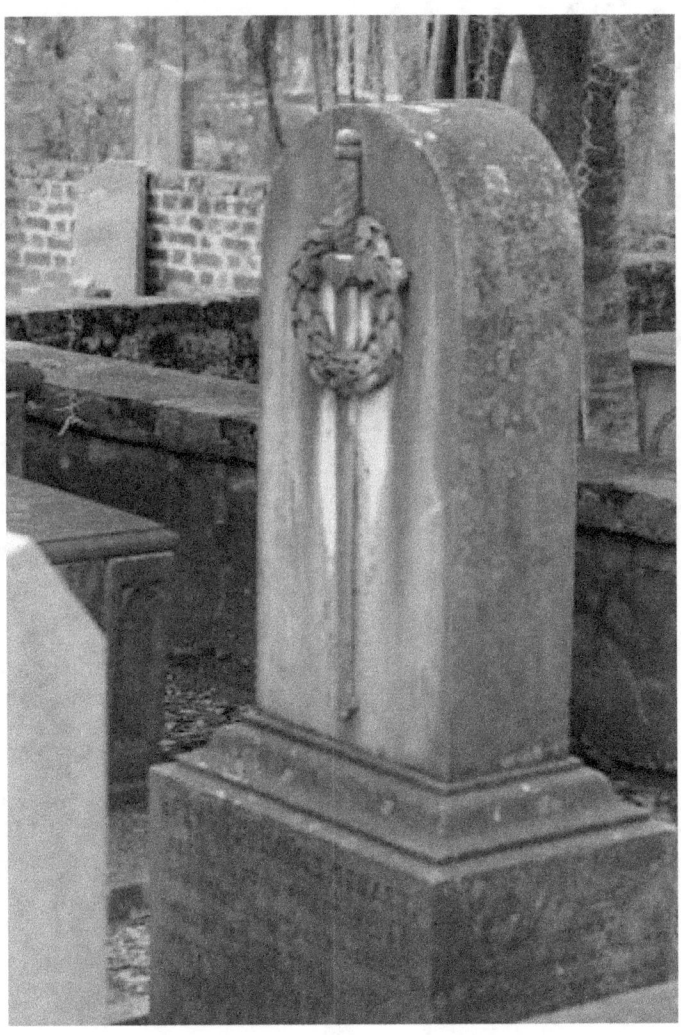

Some markers are eloquent in their simplicity, such as this one erected for a young man who emigrated from Ireland to California in 1849 to strike it rich in the gold rush—only to die a few years later in 1852 of smallpox.

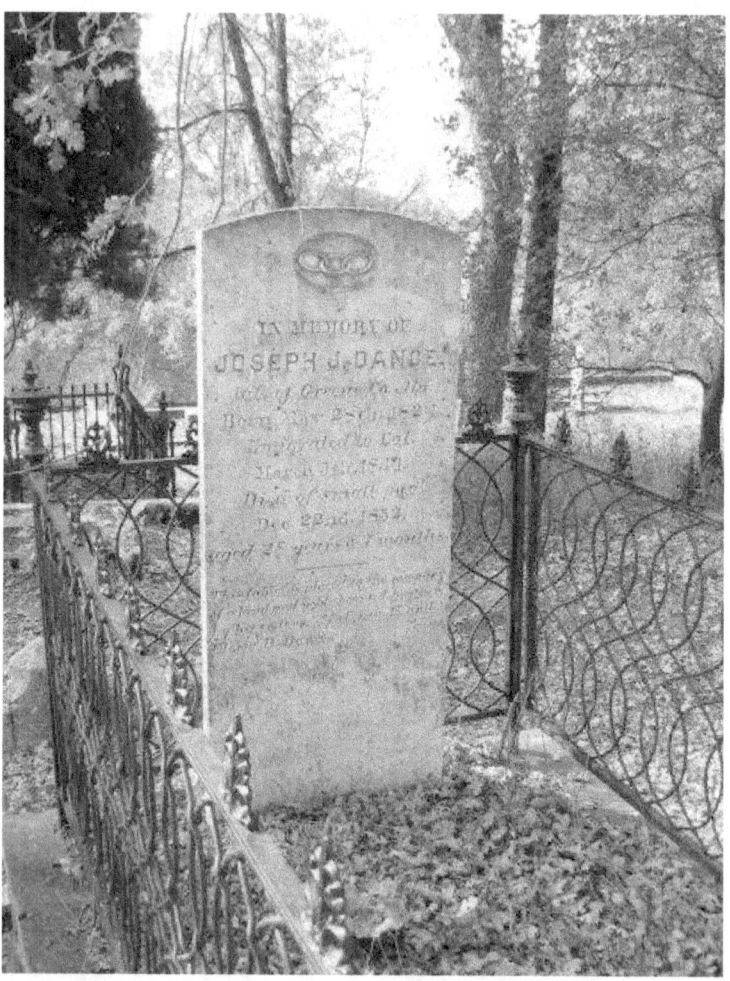

Perhaps this is the most fitting of them all as it is a story of hope, failed dreams and a promising life cut short.

The three links of chain which appear at the top center of the marker is a symbol of Freemasonry as well as the Independent Order of Odd Fellows expressing a bond between brother members and also signifies a powerful and lasting unity. This motif is found elsewhere and is said to represent the Holy Trinity and the binding of the faithful to God. In California, however, the linked chain is almost entirely connected to the two fraternal organizations and became popular during the Gold Rush. The photo below shows an IOOF building in Placerville, California which was the center of the 1848 Gold Rush.

Our heroes often have significant or historical events depicted on their monuments—not always based on reality but on National Mythology. George Washington is often depicted in full uniform next to God in heaven or armed with the angels to fight evil.

Daniel Boon's grave monument in Frankfort, Kentucky is more down-to-earth and has two panels showing his renowned Indian fighting days.

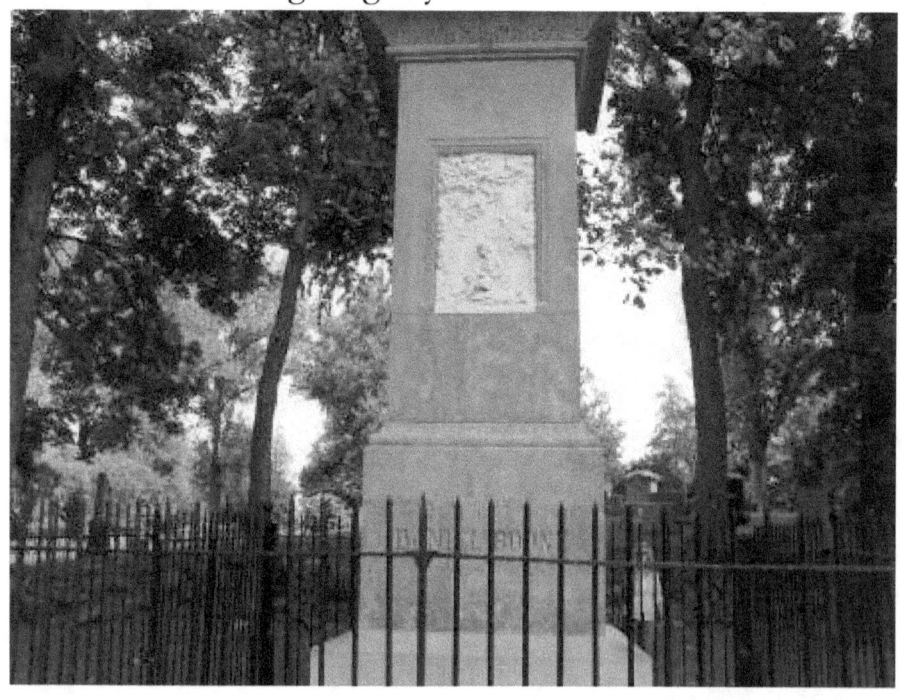

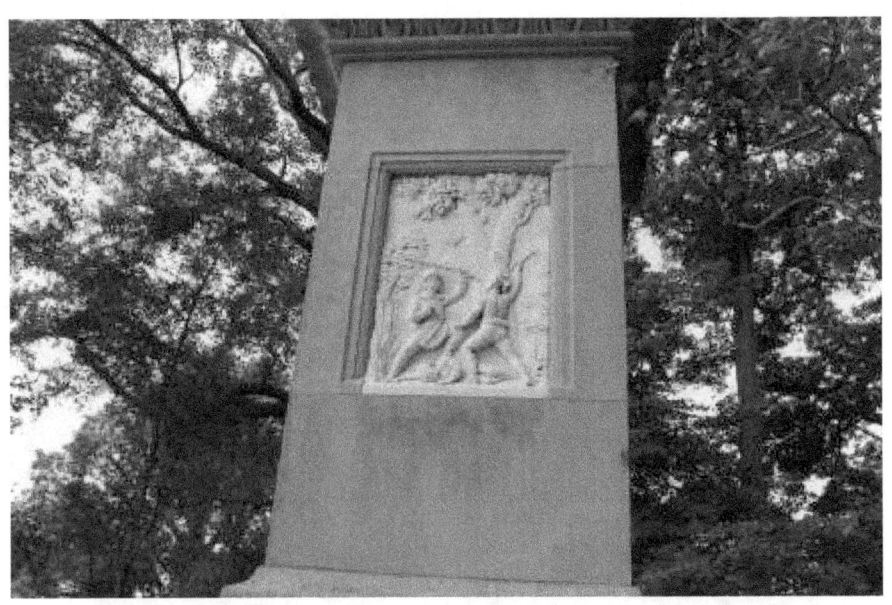

Everyday animals depicted on markers are seldom seen but can be found in colonial graveyards. While doves, sheep and dogs are common alongside the more mythical beasts others, such as the spectral owl shown below, also are present and bring their own symbolic meaning. In this case the owl, long a harbinger of death to Native Americans, represents a warning of impending death.

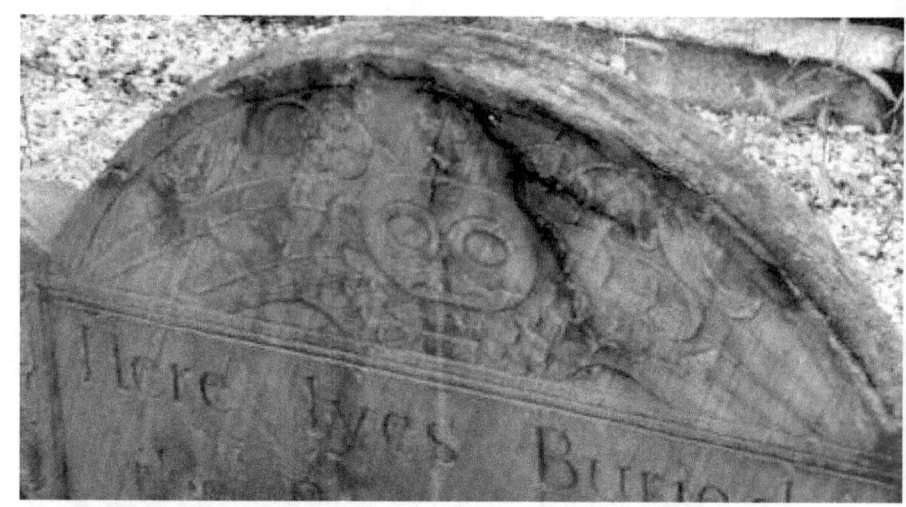

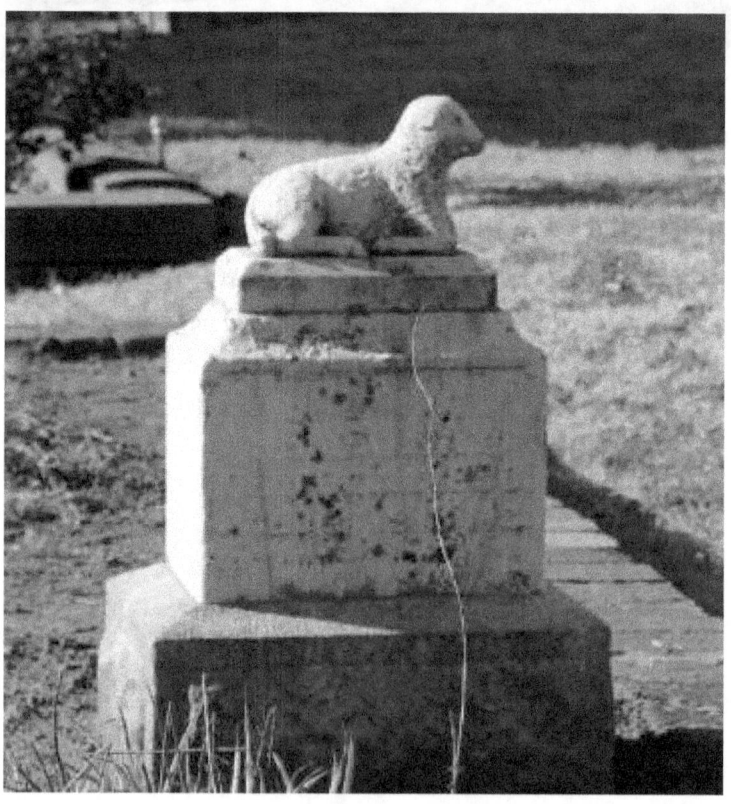

The lamb has many meanings in the graveyard. It is the emblem of the redeemer and symbolizes innocence and resurrection as well in Christian lore.

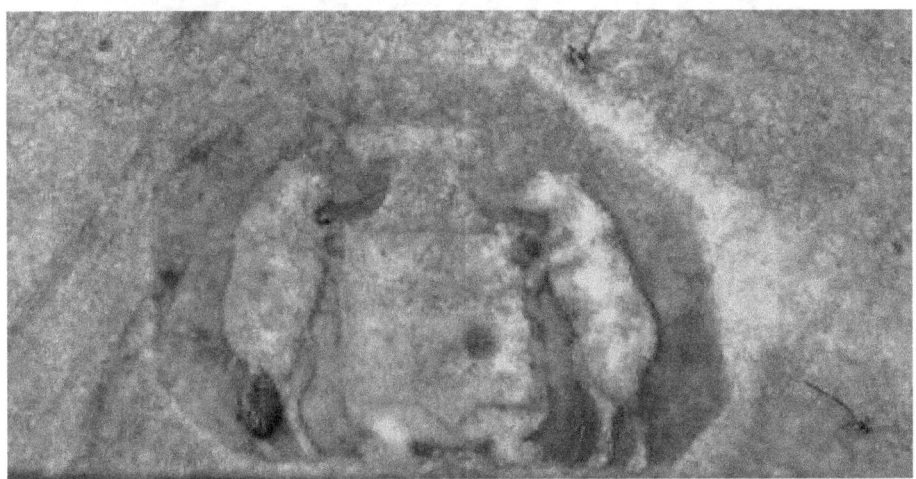

Two curious small animals were carved into this stone marker located at St. Philips Church Cemetery, Charleston, South Carolina dated 1801. Appearing as standing pigs, their specific significance is unknown, however swine normally represents gluttony, greed, lust, unbridled passion and the unclean.

While rarely found, when pigs do appear they often assume a human form. It would seem unlikely that the grave pictured on this, and the next two pages contain someone of that nature however as the deceased was a member of the Royal Military Order of St. Louis. The order was awarded to

the deceased for protestant officers in the service of the French king.

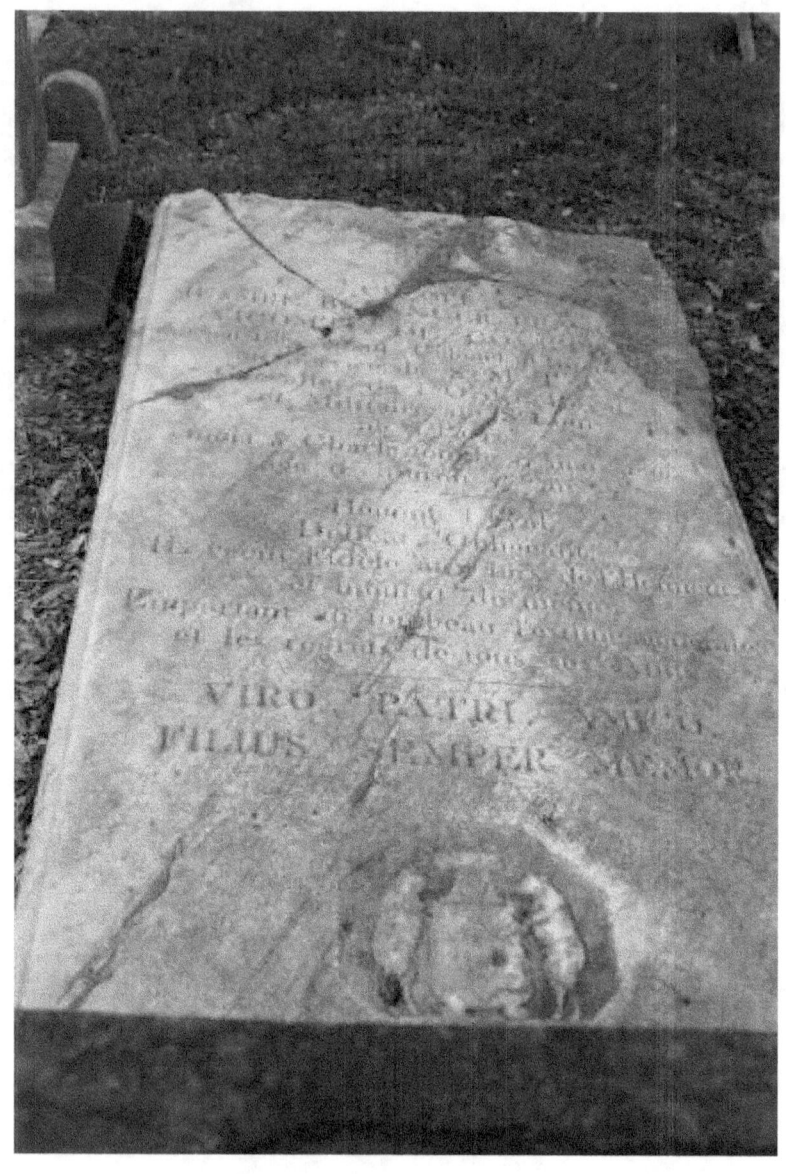

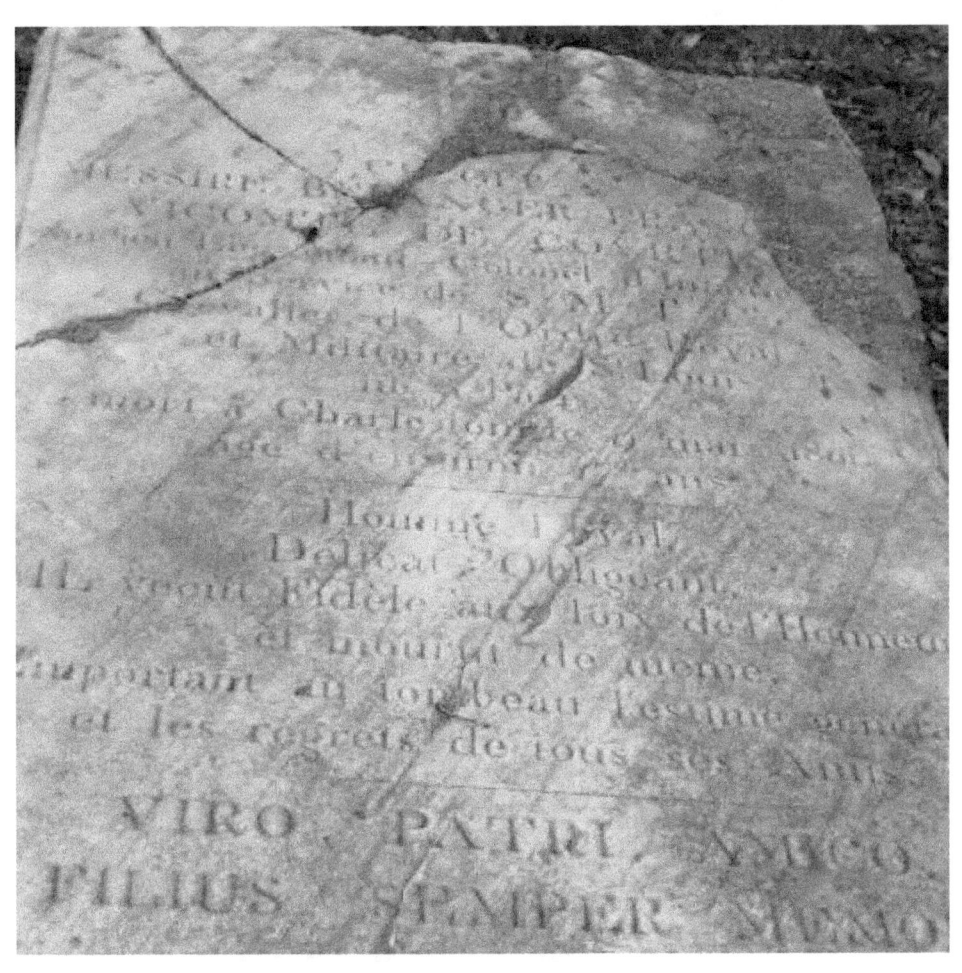

There are many other motifs in gravestone design including Art Nouveau and Celtic motifs such as seen in this photograph. The stylized garland shown was adopted by Christians from the ancient Greeks as a symbol of the victory of redemption.

Urns and cross are the two most common symbols in the graveyard. The cross of course represents Christian faith and redemption. Other cultures also utilized the symbol for their own religious purposes such as the Aztec symbol for the rain god. Often the cross is created with branches or ivy entertwined around it which is symbolic of the blood of Christ and the sacraments.

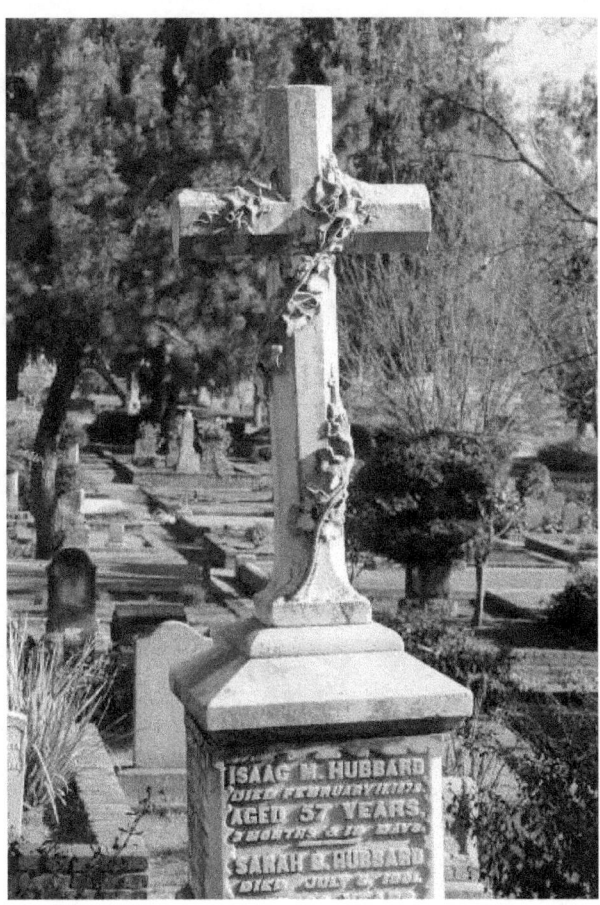

The urn is a classical image symbolizing mourning and as a repository for the ashes of the dead. The drape on the urn below signifies the veil between life and death.

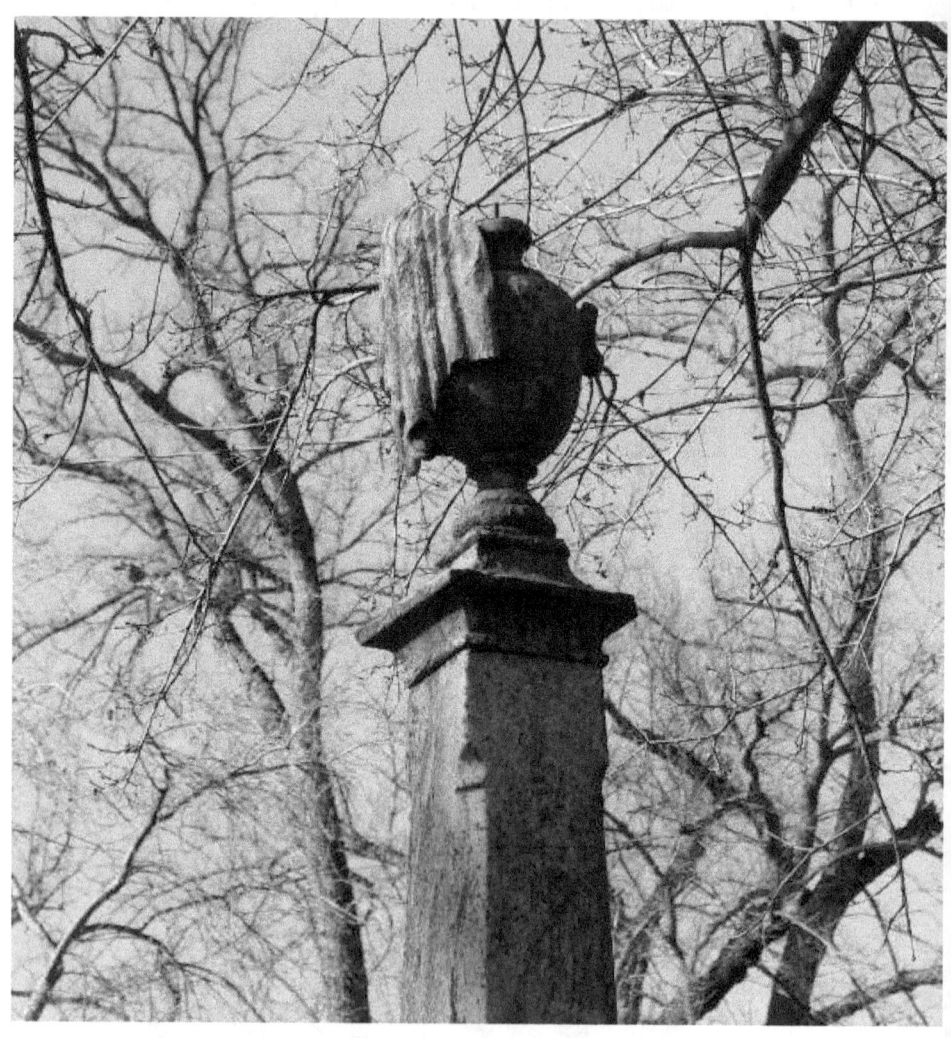

The cemetery landscape itself is symbolic with the use of vegetation representative of both death and immortality and architecture which may be given to classical styles such as Greek, Egyptian or mimicry of the Gothic cathedral. They have their own allure filled with history, with the images that were important to or defined the individual. Markers are placed where people were buried 100, 200 or 300 years in the past and sum up the entire history of our nation—both the heroic times and our times of shame. The Salem Witch Trial memorial in Salem, Massachusetts illustrates one of those times of shame:

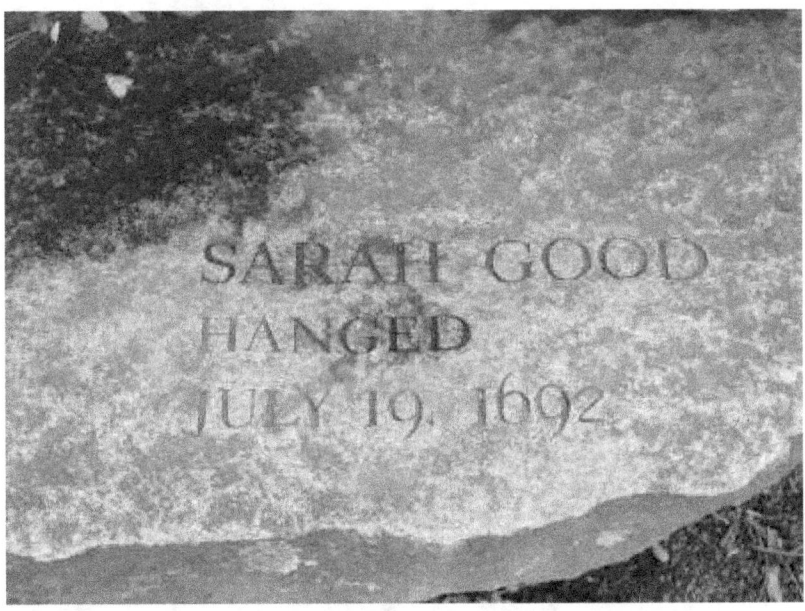

While not artistic in their form, at times simple words are the most profound.

A rather sad example of simplification is the grave marker for "Rosa May." Erected in 1860 in the ghost town of Bodie, California. There is no other indication of who Rosa was or her story.

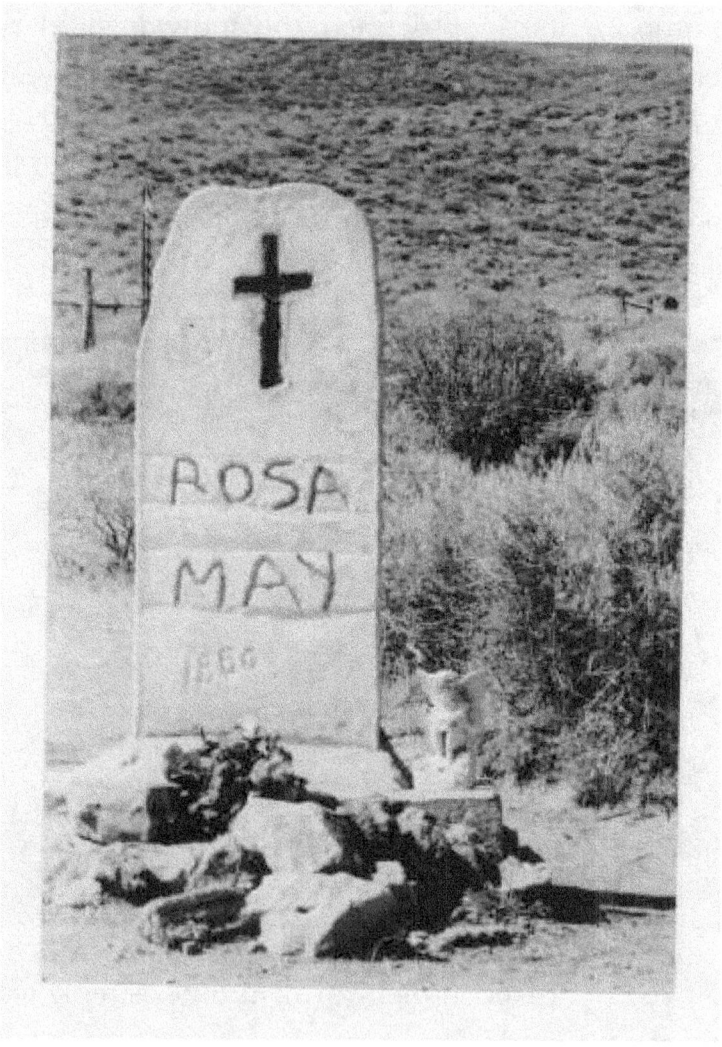

Photo by Brenna Varner

Unusual Tombs & Monuments

While the majority of graves today are of a set design and layout this is a fairly recent development in burials. In the ancient world dolmen, standing stones and intricate carvings were commonly used—especially for those who had wealth and or power. Today those methods have mostly given way to simple, flat metal plaques which state the name, birth and death dates of the individual but little else.

Pre-19th century burials, however, were of a different sort with intricate designs engraved in stone as well as tombs which maintained their prehistoric ancestry. Even the crudest stone work holds a special place today.

Barrel tombs were used in pre-19th century England and United States. The photo below shows barrel tombs from the early 18th century located in Beaufort, South Carolina.

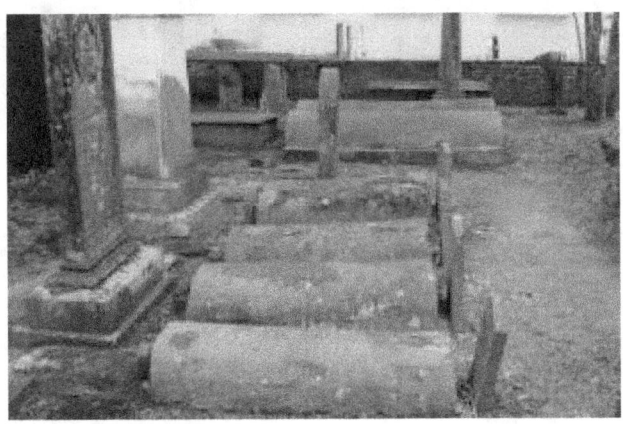

Mausoleums became popular in the late 17th century and were made to mimic classical buildings or more ancient tombs. The two shown below are free-standing brick mausoleums built to represent a country cottage complete with a lichen covered roof.

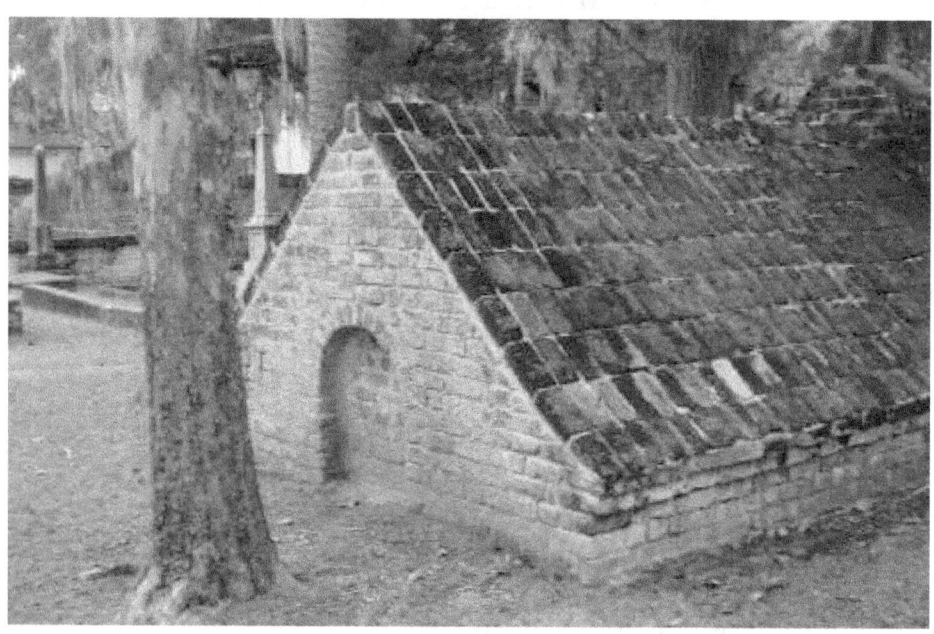

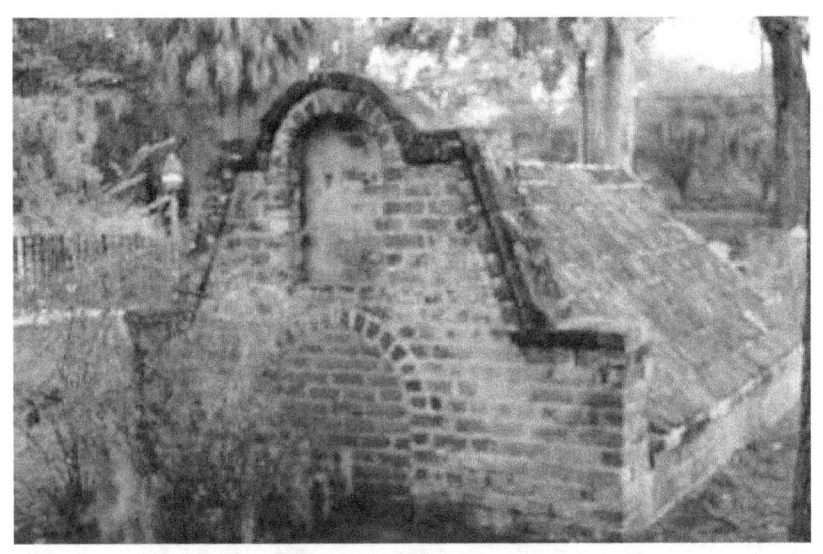

An Irish cottage such as this was perhaps inspiration for 18th and 19th century mausoleums.

Another unusual style not often seen today is the table or chest tomb which appears very much like the ancient dolmen. This particular tomb consists of four to six columns which support a top "ledger" and has no side panels. The deceased is actually buried in the ground under the tomb. The example shown below, located in South Carolina, was also popular in northern England.

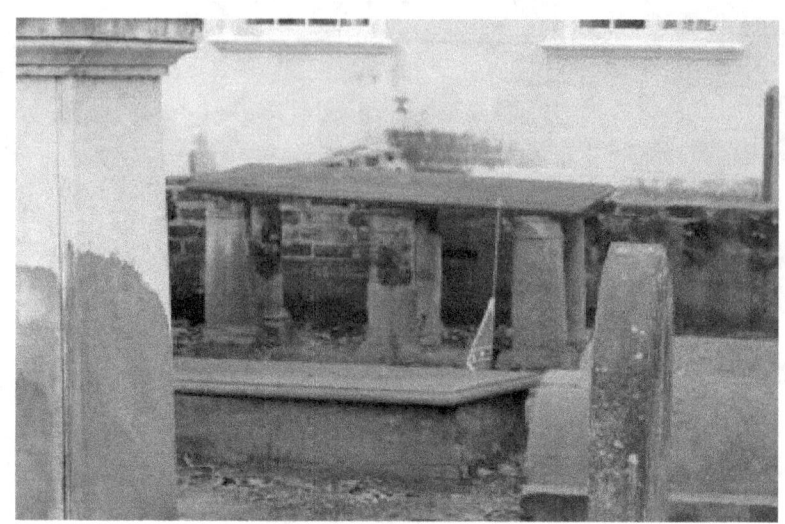

Chest or table tomb.

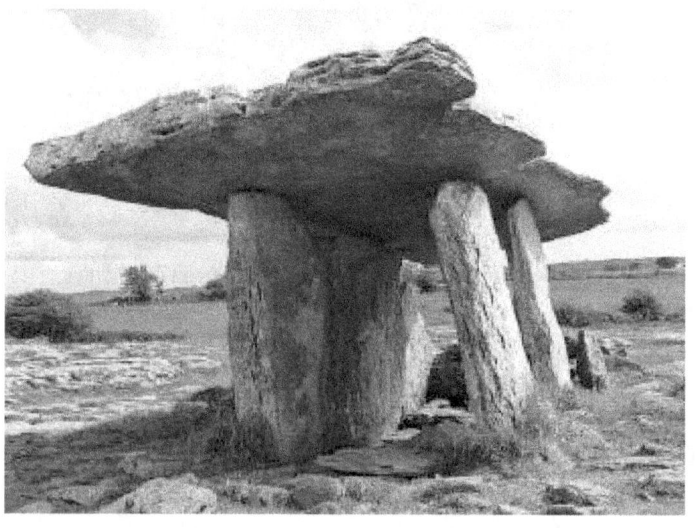

Prehistoric dolmen from County Clare, Ireland showing the continuation of the table tomb design through time and geography. Photo public domain.

While rare elsewhere many table tombs are present in the Palisado Cemetery in Windsor, Connecticut.

Table tombs are subject to natural decay due to the weight of the top slab which over time causes it to crack and break. I am not aware of any table tombs west of New England and the southeastern United States.

More traditional chest tombs are still in use today and may be extremely simple and plain or decorated with a wide variety of symbols and designs. The chest tomb below, belonging to a Confederate Lt. General killed during the Civil war is a typical example.

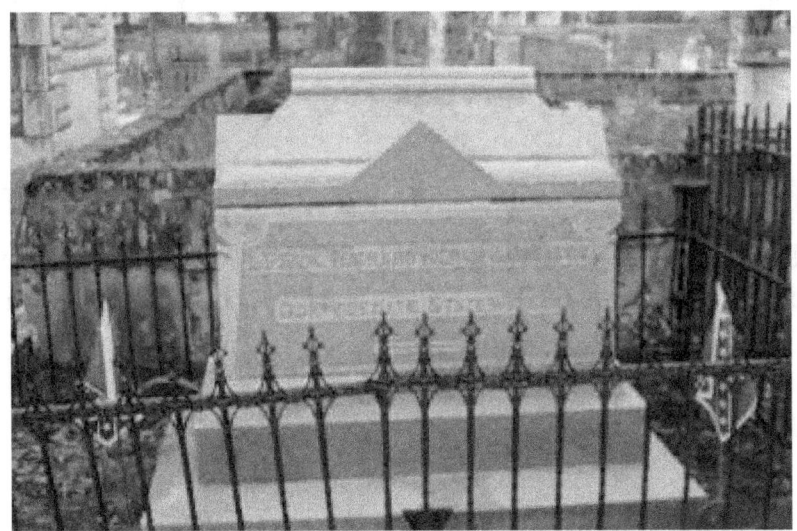

Chest tomb of Civil War General, South Carolina.

A later chest tomb with twelve stars symbolizing the twelve apostles. On the reverse is a carving of the three-linked chain.

Victorian era mausoleum-chest tombs are commonly found in high water table locations in the United States such as those in New Orleans shown below. (Photo courtesy Helen Vaughn)

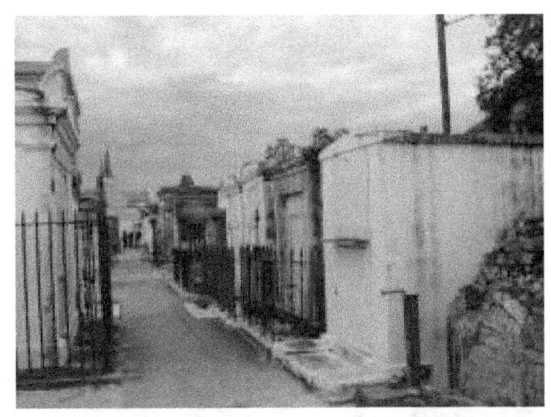

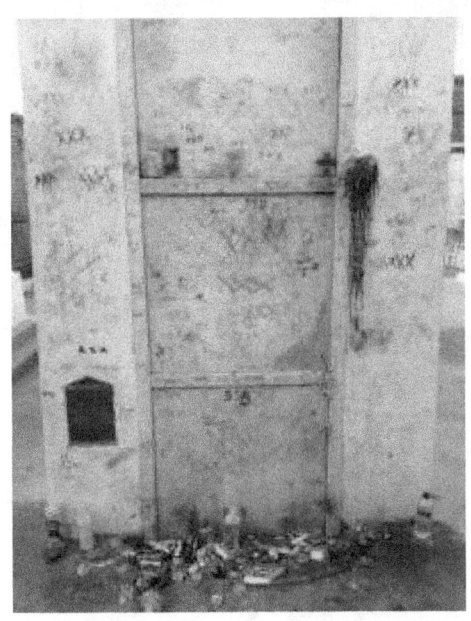

Purported tomb of voodoo queen Marie Laveau located at St. Louise Cemetery, New Orleans, Louisiana. (Photo courtesy Helen Vaughn). Ritual graffiti, offerings and ritual items continue to be left for Marie into the 21st Century.

One rather rare and macabre example of 19th century entombment is that of the glass case. The three examples shown below are located at Kingston Presbyterian Church in Conway, South Carolina and date to the 1850s. In order to continue to see loved ones after death the body was laid out in a table tomb with glass panels front and back.

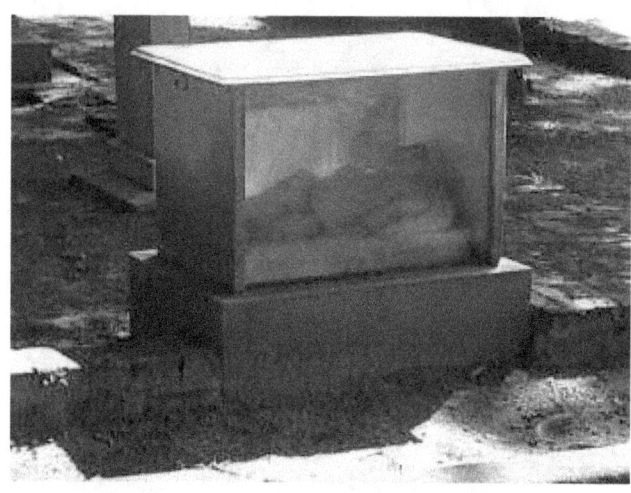

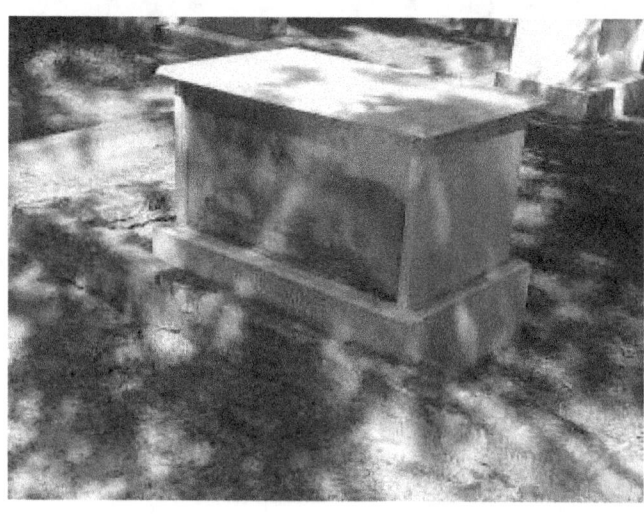

This tomb has "Our Children" carved on the base.

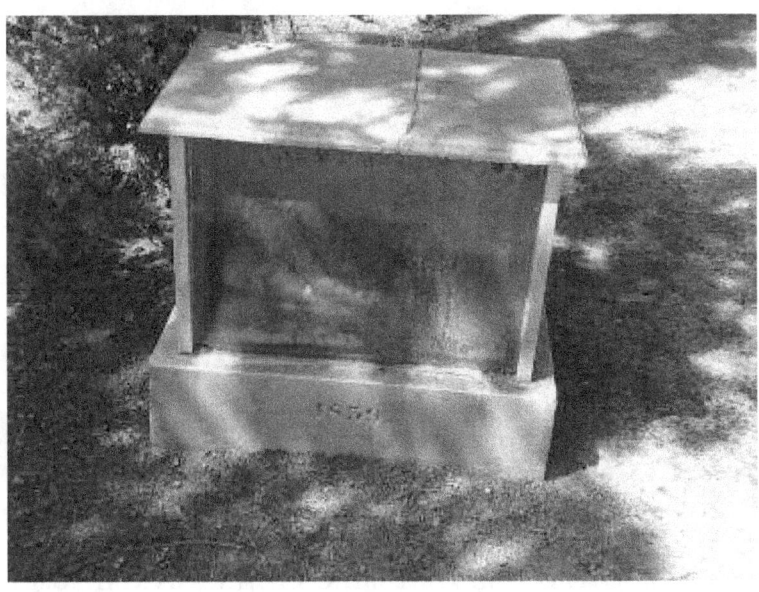

Constructed in 1858, Kingston Presbyterian is a beautiful Greek Revival church situated on the bluff overlooking the Waccamaw River.

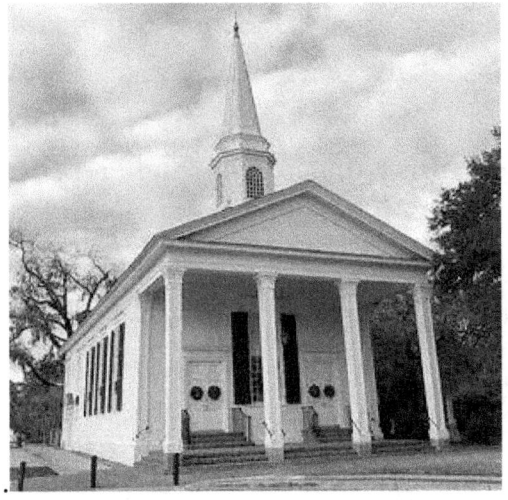

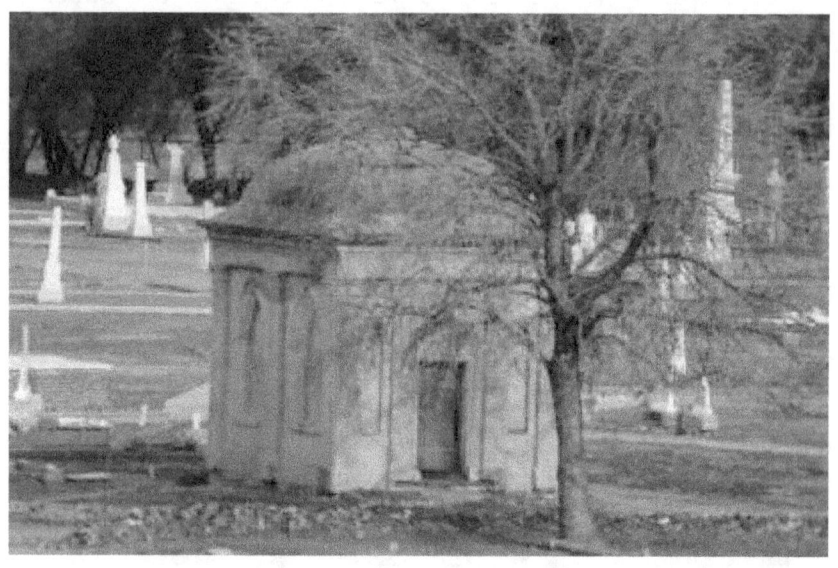

The image above is that of a large Gothic style mausoleums ca. 1850 set among obelisks, Marysville Cemetery, Marysville, California. Over 10,000 people are buried here although most rest in unmarked graves.

Gothic architecture was most often used in the 19th century because architects were able to construct large buildings that fit their budgets. Today these same buildings would be prohibitive due to the higher prices required for similar materials.

Another more rare tomb reserved for the wealthy is that of a Greek Revival mausoleum located in the Oak Grove Cemetery at Falls River, Massachusetts.

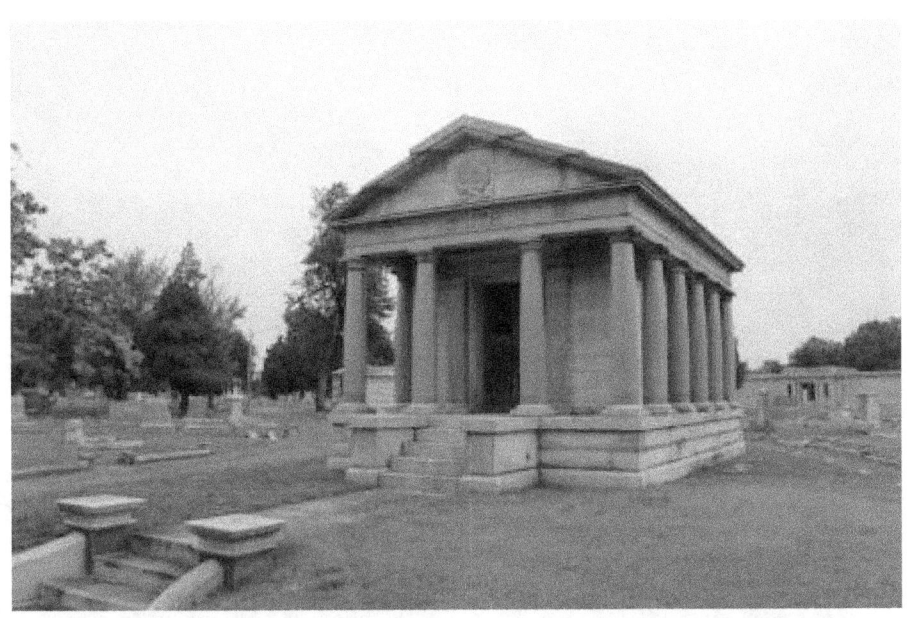

Greek Revival tomb. Oak Grove Cemetery, ca. 1840.

The obelisk became popular monuments in the 1840s and 1850s with the appearance of Egyptian Revivalism. Regarded as one of the "most pervasive of all revival forms" it was born of Napoleon's Egyptian campaigns in 1798 and 1799. Because of its ancient association with the gods and goddesses of Egypt it was condemned as heathen when first erected.

Standing stone marker. Note Star of David with inset cross. Oak Grove Cemetery.

The Marysville Cemetery has a large number of obelisk style markers and tombs dating to the 1850s.

To assuage the Christian community, many of the designers of Egyptian Revival tombs engraved Christian symbols on the tomb or in front of it.

Many Egyptian obelisk tombs dot this Frankfort, Kentucky cemetery.

After the obelisk became an acceptable symbol, its qualities overcame any existing criticism. According to Jessie Lie Farber, "Obelisks were considered to be tasteful, with pure uplifting lines, associated with ancient greatness, patriotic, able to be used in relatively small spaces, and, perhaps most importantly, were less costly than large and elaborate sculpted monuments." [20]

Obelisks came to symbolize the connection between heaven and earth, death and rebirth.

[20] Farber, Jessie Lie. "Symbolism on Gravestones." Association for Gravestone Studies http://www.gravestonestudies.org

Many cemeteries have large monuments and statuary dedicated to those who died in battle as well as the influential and wealthier citizen.

The monument shown on the next page is dedicated to the "Grand Army of the Republic" located in Sacramento, California.

The Grand Army of the Republic was a fraternal organization founded in 1866 composed of veterans of the Union Army, US Navy, Marines and Revenue Cutter Service who served in the American Civil War.

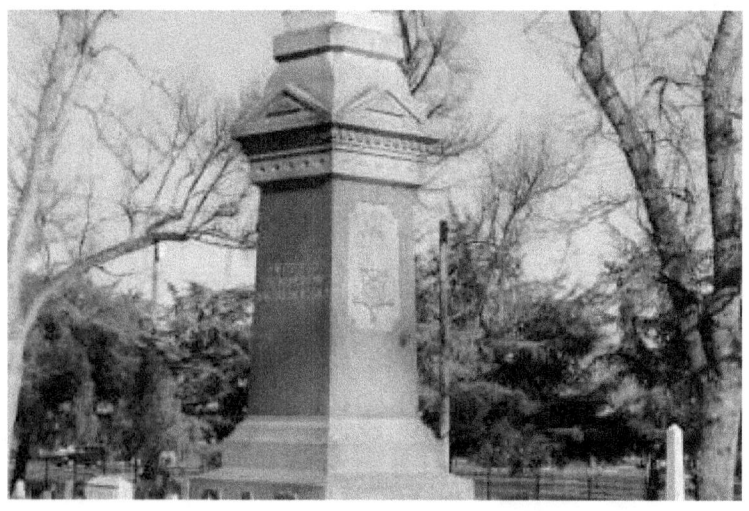

Base of the Grand Army of the Republic monument. "Dedicated to the memory of our soldiers dead."

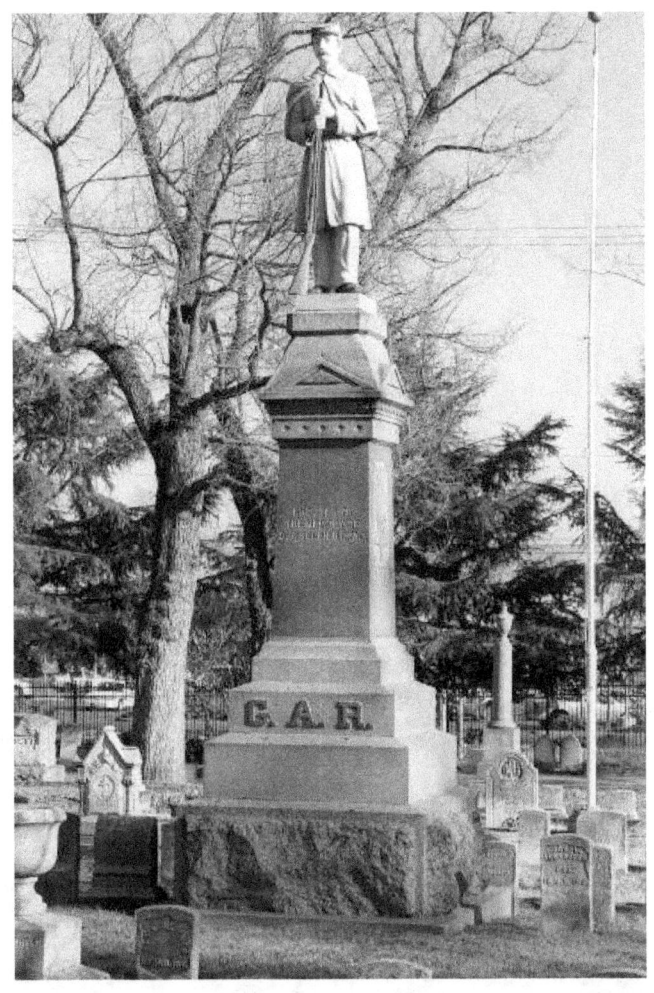

The Confederates had similar memorials such as the one next page located in Perryville, Kentucky—the site of a terrible battle of the Civil War.

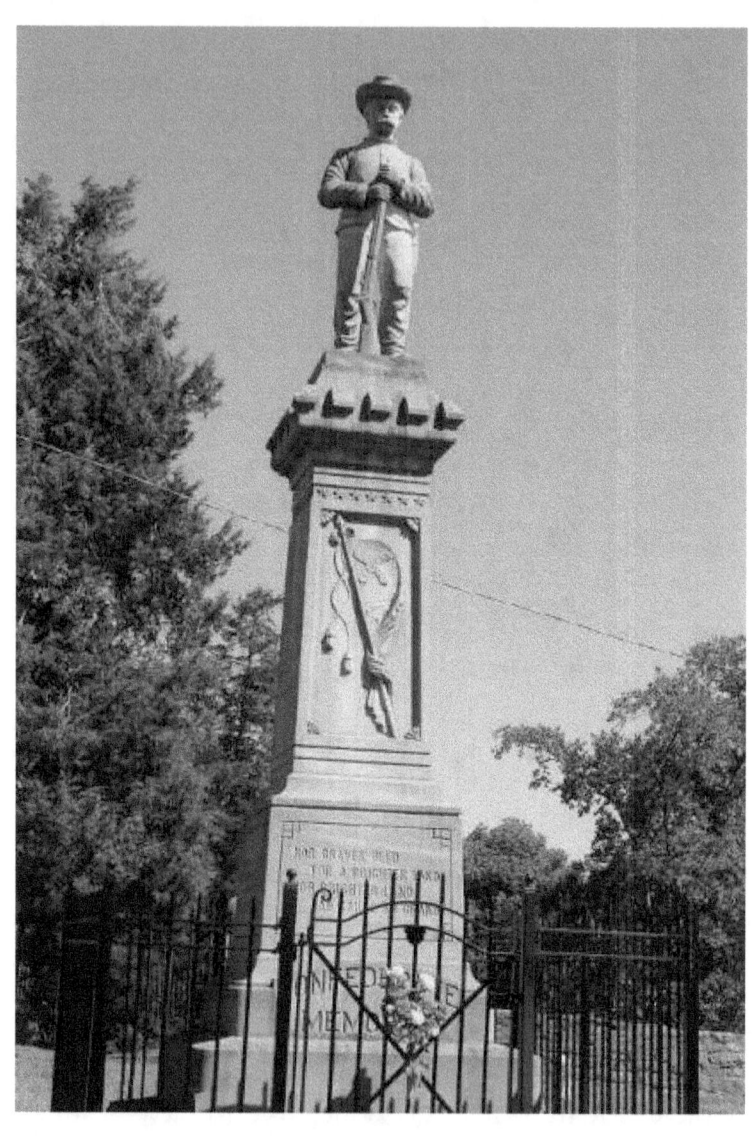

Confederate Monument, Perryville, Kentucky Battlefield

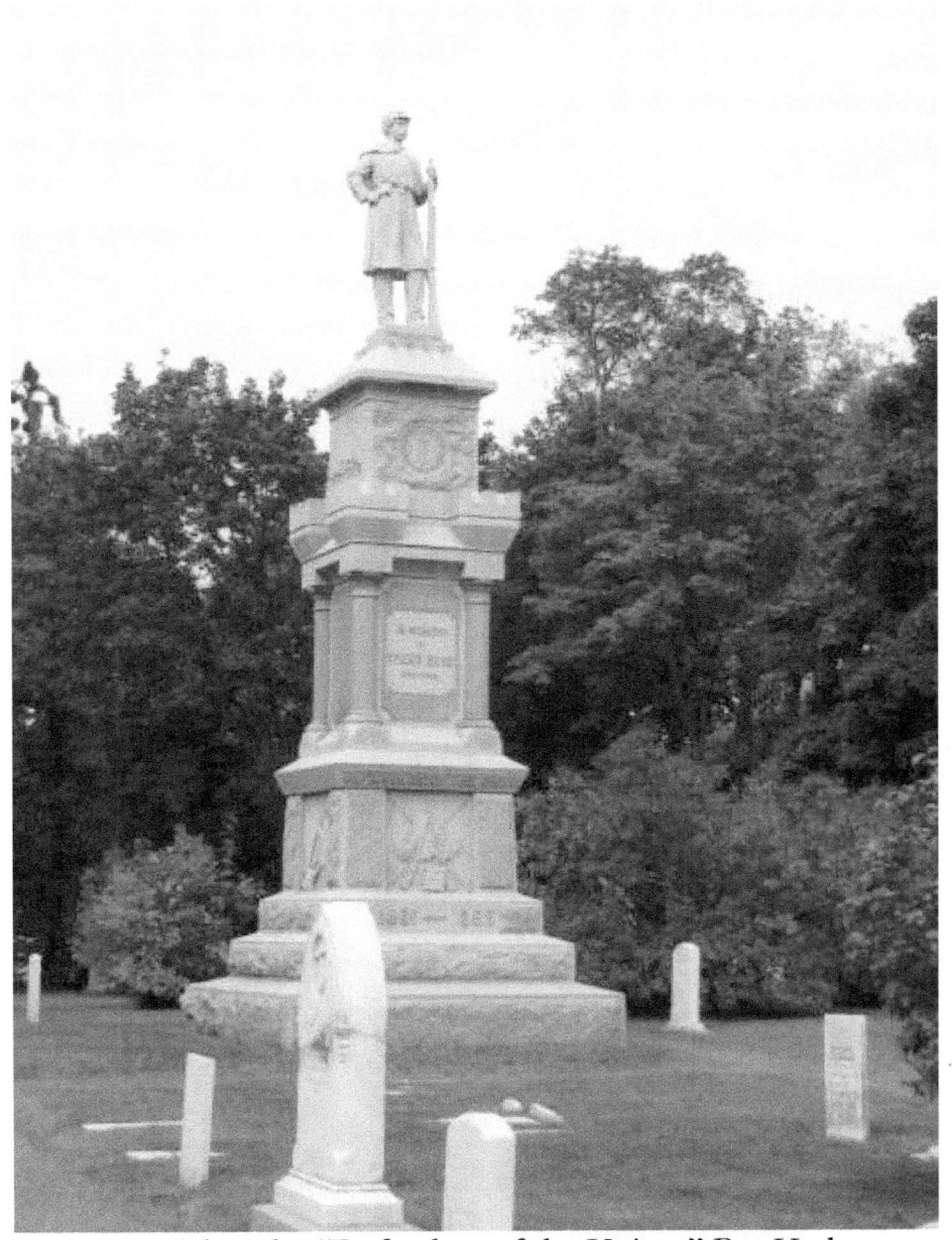
Memorial to the "Defenders of the Union," Bar Harbor, Maine.

Statuary is commonly found in our cemeteries and provides another link to classical themes that are expressive of human emotion. The mourning figure on the Crocker memorial, as this monument typifies, is a typical early 20th century funerary image.

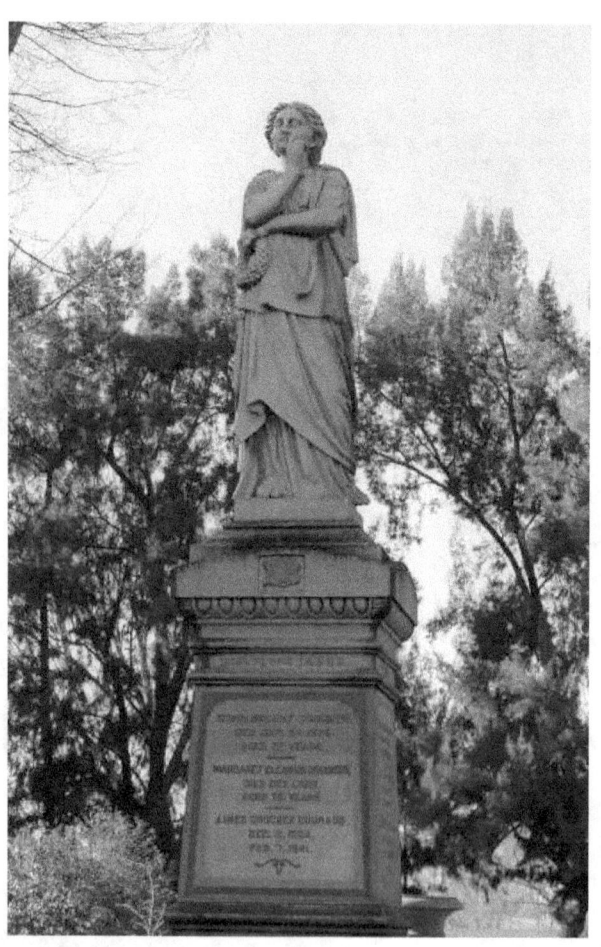

Memorial for the Crocker family in Sacramento, California. The weeping woman is holding a wreath in her left hand which symbolizes passing to eternal life.

The Stone Carvers

Each gravestone found across our country was one of a kind, hand made and designed with the individual carver's sense of art and originality. Before the population increased to allow a livelihood to be eked out by cutting gravestones and for training to be developed for apprentices, those engaged in masonry work, the slating of roofs and those who made and repaired shoes and leather work as well as woodcarvers were likely hired for the task. Their individual skills resulted in a wide variety of workmanship and style.

"As a result of the apprenticeship system practiced at that time," wrote Edmund Vincent Gillon, Jr. "there emerged throughout the New England area families of stonecutters

whose craft was plied through several generations. Deeds, probate records, inventory accounts, sometimes signatures of the stones themselves, reveal some of the names of men who actively engaged in this craft. Even the work of stonecutters whose names are still anonymous has been tabulated on the basis of stylistic configurations..."[21]

Because the population of the United States has moved from the New England states to the Pacific the styles and symbols associated with New England gravestones also immigrated across the land, evolving along the way.

Some of the more well known carvers include Gershom Bartlett (1723-1798) known for his relatively bizarre carvings in Connecticut; Benjamin, Julius and Zerubbabel Collins who lived from the late 1600's to 1797 also in Connecticut; the Manning family whose works can be found in most eastern Connecticut cemeteries and whose work was widely copied. Others include the Stanclift family whose father and five sons worked through five generations from the late 17th century into the 19th century; the Lamson family from 1722 to 1767, the Allen family who worked out of their shop in Rehoboth, Massachusetts from 1720 until 1800, and the

[21] Gillon Jr., Edmund Vincent. *Early New England Gravestone Rubbings.* Mineola: Dover Publications, Inc. 1981, x.

Steven's who were the first known stone carvers in Rhode Island during the mis-1600s to 1736.

There were dozens of carvers at work in New England who contributed to the designs and folklore associated with gravestones. Some produced rather bizarre pieces. Gershom Bartlett produced stones in Vermont and New Hampshire creating heads with bulbous noses, rows of teeth in jawless faces, raised eyebrows, and protuberances that sprouted from the sides of the heads. Others such as the "Glastonbury Lady Carver" made faces which resembled scarecrows or pumpkins.

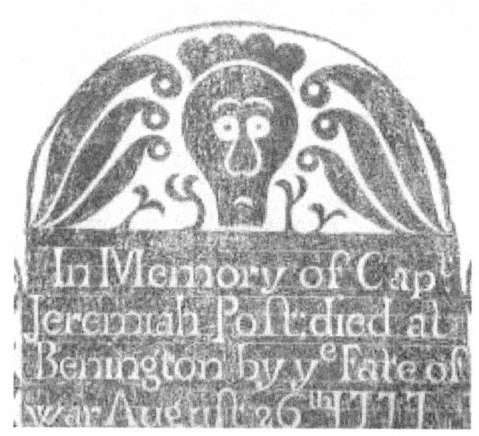

Rubbing of gravestone carved by Gershom Bartlett.

The first known carved gravestone was completed in 1647 and was probably carved by Richard Drummer of Newbury, Massachusetts. Richard also made door stones and mile markers. Two of his stones are regarded as "the

earliest known examples of carved art in colonial America." Drummer was a wealthy man but also generous to the poor. He was instrumental in the establishment of the towns of Newbury and Hampton (NH) as well as setting up mills. He also served as a judge and Governor's Assistant and town treasurer. In 1637 Drummer ran afoul of the Puritan's who declared that Drummer and sixty others surrender their guns and ammunition unless they admitted their "sin"—the "sin" was one of progressive thought. Rather than disarm Drummer left for England but returned the next year (1638) and built a manor house on his 500 acre farm. Over time, and through many disputes with local government and courts, Drummer amassed over twenty-six hundred acres in Newbury, Watertown, Billerica, Saugus and Roxbury. Drummer and his sons eventually carved milestones to serve as points of reference for travelers and they became some of the first public art works in New England. They stand out not only for their artistic renderings which were viewed as show pieces but for their eventually use as advertisements for taverns. Drummer is regarded as "one of the fathers of Massachusetts".

Dozens of stone carvers contributed to the art from Drummer's time and as others learned and created their gravestones their craft spread across the country.

The carver's art moved westward as Gold Rush fever erupted in California in 1848. Those who sought gold brought with them their desire to have gravestones which they were familiar with in their homelands—mostly from New England. One of the talented carvers who set up shop in Sacramento was Israel Luce who had learned how to carve stone in New York and Massachusetts. Luce arrived in San Francisco in 1851 where he purchased marble and had it shipped to Sacramento. Luce set up shop with Andrew Aitkin and together they produced many stones in the Gold Country—all signed "Aitkin." Their business thrived until 1878. Reportedly Aitkin had one of the largest marble yards in California.

Another eastern stone cutter by the name of Edwin Roberts came to California from Connecticut setting up his shop in Columbia, California in 1854. Columbia was a major mining town at the time. Ironically Roberts died a poor man and was buried without a gravestone.

Grave Study Considerations

Grave stone studies are becoming more and more popular today for people interested in history and art history in particular. Civil war and Revolutionary War battlefields draw people by the thousands as do the associated graveyards. For those really interested in the study there is

even a professional organization, The Association for Gravestone Studies provides conservation workshops, tours of historic sites, lectures and a series of publications. For more information, including membership, write to the following address:

<div style="text-align:center">

The Association for Gravestone Studies
278 Main Street, Suite 207
Greenfield, MA 01301

</div>

Grave studies have become very popular over time and people have taken camera in hand to record their own local gravestones or taken rubbings of the stones for framing or for other collecting purposes. Some helpful tips for successful rubbings include:

- Clean the stone with soft brush to remove excess dirt
- Spray the dirt off with a water bottle then gently wipe the stone with a cloth
- Tape a large piece of paper of the area to be copied (be careful not to lean on the stone while doing any of these steps and you should not attempt to take a rubbing from any thin or cracked stones)
- Rub from the outside edges
- Remove paper and trim as desired

Some areas do not permit rubbing as damage can be inflicted and if not careful the chalk or crayon being used may transfer to the stone. You should always seek permission before undertaking tombstone rubbing and always show respect.

There is "cemetery etiquette" which should be common sense, but it should be restated anyway. Make sure you observe all posted speed limits and rules, including entrance and exit times. Be courteous and avoid any mourners so that they may visit with their loved ones in peace.

Leave all offerings where they are. Coins, candles, photos and other items left by mourners belong to them. Pick up your trash and any other litter you may see so that the beauty of the cemetery will remain for others. Do not walk on the graves but carefully walk around them.

Report any vandalism to the cemetery staff or the police department. If you are requested to refrain from taking a rubbing or photograph respect the request and don't do it.

Vandalism is a terrible thing no matter where it occurs and what is destroyed. But not all vandalism is due to hate or vile characters. An Englishman in 1861 wrote to the British periodical *Notes & Queries:*

"Some years ago I was seeking in the churchyard of an old parish in the north of England for some ancient tombstones belonging to my own family, and was surprised and grieved at not being able to find any, except of a much more recent date than those I was most anxious to see, and which I knew were in existence but a few years before. As these stones were among the very oldest in the church-yard, I mentioned the fact to the vicar...and upon my expressing a fear that they had, in some unaccountable way, disappeared, he replied very coolly, "nothing is more probable, for it is a rule with us to destroy the oldest stones, to make room for the new."—H.E. Wilkinson [22]

The Connecticut Gravestone Network offers some sound advice concerning vandalism:

"Should we wait till half a cemetery is destroyed to speak out, or only be concerned when it is a more modern cemetery? After all, the old memorials are weathered and OLD. And there probably isn't any family left that cares anymore anyway.

We all know that after dark a cemetery is far too "spooky", and all adolescents would not dare enter this

[22] Notes & Queries August 3, 1861, pg 92

sacred ground. (Sounds like a challenge most teens would have to meet.) The more curious, adventurous, lonely, rowdy and "just for the heck of it" type teens see the cemetery as a place of refuge. They're the only ones brave enough to go there after dark and defy society. It's a place to gather, smoke, drink and not be hassled by adults. It's been like this for generations. A community needs to foster an attitude that lets these teens know that respect is part of the program. If they learn how to appreciate the local cemetery and the history it holds, instead of the emphasis being on death and scary ideals, perhaps we could curb some this destructive energy.

What can you do?

- Take an afternoon walk through your local cemetery with the family. Introduce your children (and yourselves) to the who's who and the artwork that's there to be admired.
- Visit the local library or historic center and find a connection that interests the children in having a connection with their local history. Do a mystery or treasure hunt, if you will, about finding a particular stone.
- Introduce your local history teacher to the thought of using your local outdoor museum for a history lesson.
- Encourage your local police to patrol the cemetery more often. Notify the police and your local cemetery

authority when you see even one new toppled stone or similar problem.

When the word gets out that someone does care and is watching - problems will lessen." [23]

Remember these are sacred areas and should be respected and protected.

[23] http://www.ctgravestones.com/index.html

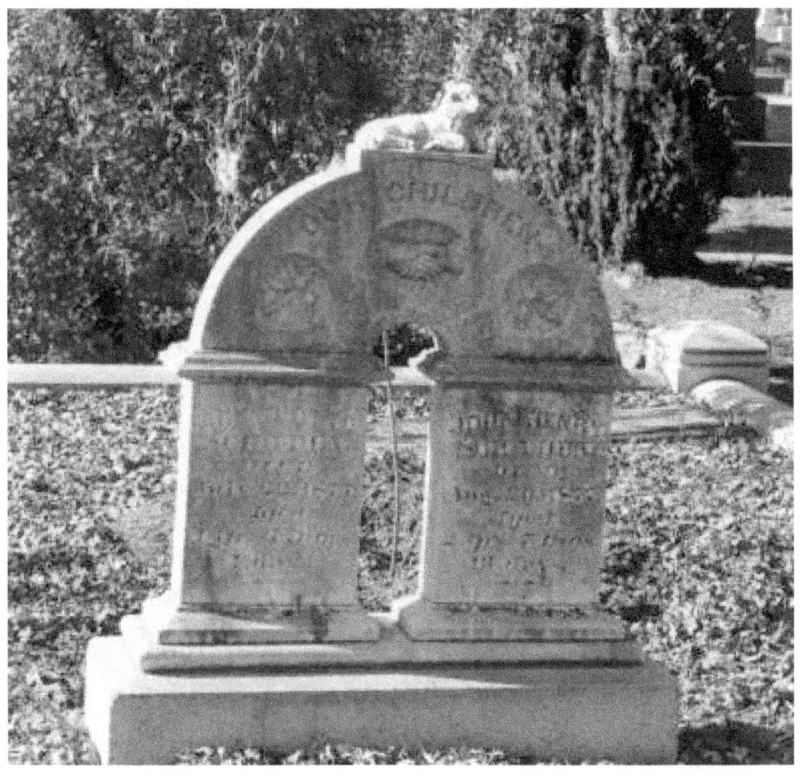

Gravestone with multiple symbols for two infant children who died a month apart in 1877.

Bibliography

AGS Field Guide No. 8: Symbolism in the Carvings on Gravestones. Greenfield: The Association for Gravestone Studies (AGS) 2003

Biedermann, Hans. *Dictionary of Symbols: Cultural Icons & the Meanings Behind Them.* New York: Meridian 1994

Cooper, J.C. *An Illustrated Encyclopaedia of Traditional Symbols.* London: Thames and Hudson 1978

Eriquez, Christina. *Our History in Stone: The New England Cemetery Dictionary.* Brookfield: The Dark Ages of New England Books 2009

Evans, E. P. *Animal Symbolism in Ecclesiastical Architecture.* London: W. Heinemann 1896

Farber, Jessie Lie. "Symbolism on Gravestones." Association for Gravestone Studies http://www.gravestonestudies.org. n/d

Gage, Mary Elaine and James E. *Stories Carved in Stone.* Amesbury: Powwow River Books 2003

Gillon Jr., Edmund Vincent. *Early New England Gravestone Rubbings.* Mineola: Dover Publications, Inc. 1981

Goodrich, Deborah. *Cemetery Art and Symbolism in North America.* n/p 2003

Keister, Douglas. *Stories in Stone: A Field Guide to Cemetery Symbolism and Iconography.* New York: MJF Books 2004

Miller, Mary and Karl Taube. *An Illustrated Dictionary of the Gods and Symbols of Ancient Mexico and the Maya.* London: Thames and Hudson 1993

Potok, Chaim. "Foreword" in *Graven Images: Graphic Motifs of the Jewish Gravestone* by Arnold Schwartzman. New York: Harry N. Abrams, Inc. 1993

Schwartzman, Arnold. *Graven Images: Graphic Motifs of the Jewish Grave Stone.* New York: Harry N. Abrams, Inc. 1993

Tresidder, Jack. *Symbols and Their Meanings.* New York: Barnes& Noble 2006

Vincent, W. T. *In Search of Gravestones Old and Curious.* London: Mitchell & Hughes 1896

Yalom, Marilyn. *The American Resting Place.* Boston: Houghton Mifflin Company 2008

Yorke, Trevor. *Gravestones Tombs and Memorials*. Berkshire: Countryside Books 2010

About the Author

Gary R. Varner is a traveler in search of mysterious places of power and symbolism. He has journeyed to England, Wales, Ireland, Canada, Yucatan and across the United States to visit the places he writes about and to capture them in photographs. Among the books he has written on folklore, mythology and symbolism include the following:

Menhirs, Dolmen and Circles of Stone: The Folklore and Magic of Sacred Stone 2004

The Mythic Forest, the Green Man and the Spirit of Nature 2006

The Dark Wind: Witches and the Concept of Evil 2007

Creatures in the Mist: Little People, Wild Men and Spirit Beings Around the World - A Study in Comparative Mythology 2007

Mysteries of Native American Myth and Religion 2007

The Gods of Man: Gods of Nature - God of War 2007

Maria Lionza: An Indigenous Goddess of Venezuela
2007

The Use & History of Amulets, Charms and Talismans
2008

Gargoyles, Grotesques & Green Men: Ancient Symbolism in European and American Architecture 2008

The Owens Valley Paiute - A Cultural History 2009

Sacred Wells: A Study in the History, Meaning, and Mythology of Holy Wells & Waters - 2nd edition August 2009

Ancient Footprints - Cultural Diffusion in Pre-Columbian America 2010

Charles G. Leland - The Man & the Myth, 2nd edition 2010

Magic, Witchcraft, Pagans & Christians: A Study in the Suppression of Belief and the Rise of Christianity 2010

Ghosts, Spirits & the Afterworld in Native American Folklore and Religion 2010

Water from the Sacred Well: Further Explorations in the Folklore and Myth of Sacred Water 2011

The Sword and Dagger in Myth & Legend 2nd edition 2011

Hecate the Witches' Goddess 2011

Hidden in Plain Site I - Sacramento 2012

Hidden in Plain Site II - Pittsburgh 2012

Ethiopia - A Cultural History of an Ancient Land 2012

The Folklore of Faeries, Elves & Little People - A Study of a Cultural Phenomenon 2012

Portals to Other Realms: Cup-Marked Stones and Prehistoric Rock Carvings 2012

Varner has also lectured and appeared on television shows concerning symbolism and megalithic structures.

www.ingramcontent.com/pod-product-compliance
Lightning Source LLC
Chambersburg PA
CBHW072153170526
45158CB00004BA/1627